Islamic Painting : A Survey

Sultan Murat III watching dancers, from '*Surnama-i-Humayun*',
c.AD 1584. See p. 170

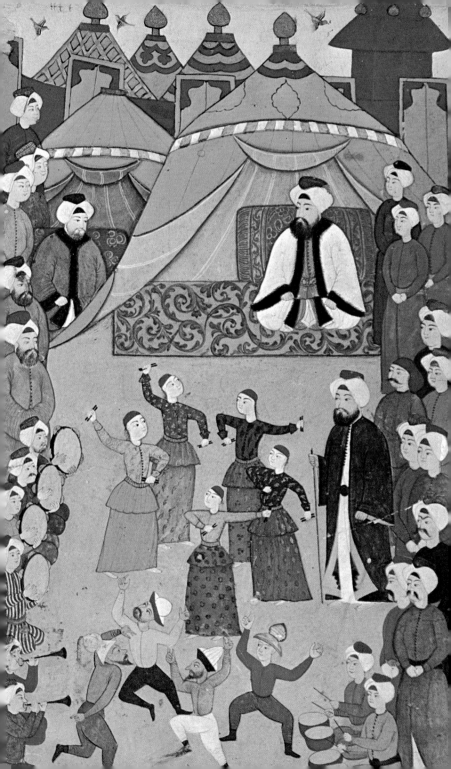

David Talbot Rice

ISLAMIC PAINTING

A Survey

EDINBURGH

at the University Press

© 1971
David Talbot Rice
EDINBURGH UNIVERSITY PRESS
22 George Square, Edinburgh
ISBN O 85224 112 7
North America
Aldine · Atherton, Inc.
529 South Wabash Avenue, Chicago
Library of Congress
Catalog Card Number 78-106477
Printed in Great Britain by
T. & A. Constable Ltd., Edinburgh

Contents

List of Illustrations

Preface

♎

The majority of the books on Islamic painting that have hitherto appeared have been primarily concerned with the more brilliant aspects of the art and have consequently dealt at greater length with the phases about which we know most and from which the largest number of fine examples have come down to us, more especially the famous age which developed in Persia between about 1400 and 1600, with Herat, Shiraz, Tabriz and Isfahan as the main centres. The balance of emphasis here is quite different, for of the nine chapters into which the book is divided only two deal with that phase, whereas the others are devoted either to early developments or to less familiar aspects, such as the story of painting in Egypt and Turkey. This is not due to any lack of appreciation of what is admittedly the most distinguished phase, but rather to two other causes; firstly, the art of the major phases is comparatively well known, several excellent accounts of recent date are available and there is little of a general character that can be added without entering into a discussion of problems of dating or attribution that are too complicated to be dealt with in a short survey; and secondly this book is primarily intended as an account of the place that figural painting occupied in the Islamic world as a whole and to call attention to the diversity of its character, rather than to deal exhaustively with the aesthetic quality of the art of any particular age. Our story thus begins with the essentially Hellenistic or Byzantine decorations that were sponsored by patrons of the Omayyad dynasty at the very beginning of Islamic history, and continues by stressing the importance of painting under the Abbasids, an age known in the main principally to archaeologists; a chapter is then devoted to Egypt, North Africa and Spain, areas that have hitherto

never been dealt with other than sporadically. The so called 'Mesopotamian' school is then examined carefully, with the object of attempting to distinguish the nature of the Arab, as opposed to that of the Persian, contribution to painting, and stress is then laid on the importance of the Ilkhanid school in western Persia, because it seems to the writer that the superb quality of its products has hardly been generally recognized. The story of the great phases of the fifteenth and sixteenth centuries in Persia is then examined, and finally an attempt is made to do justice to Turkish painting, a branch of Islamic art which has only very recently begun to receive recognition in its own right.

The book is intended as a general survey or handbook and the author has sought to collect together as much scattered material as possible rather than to attempt to probe deeply into problems of authorship and attribution. It is hoped that in so doing a gap has been filled and a useful task performed, without undue repetition of the work of others.

The bibliography at the end is conceived on the same basis as the chapters; reference is made to specialized articles which deal with fairly limited aspects of the problem so far as the earlier chapters are concerned, while in the main only comparatively recent books, which treat of painting as a whole, are referred to in relation to the better known later phases; full bibliographies necessary for specialized study are given in most of these more recent works. Reference to the library numbers are given in brackets in the case of most of the manuscripts, but in a few instances, where library numbers are lacking, references are given to the excellent book by Binyon, Wilkinson and Gray (B.W.G.). As it has been possible to include only a few colour plates here, reference is also sometimes made to the fine colour plates in two recent books in the Skira series, *Arab Painting* by Richard Ettinghausen (R.E.) and *Persian Painting* by Basil Gray (B.G.).

A word should perhaps be added about the spelling of names. As one of the main objects of this book is to introduce Islamic painting to those who are not necessarily familiar with the Islamic languages, the use of a uniform system of transliteration, including diacritical points, has seemed undesirable and the spellings most generally familiar through convention have

been followed. For similar reasons extensive footnotes have been avoided, but readers should have no difficulty in following up references to particular works of art if they turn to the bibliography at the end of the volume.

I

The Beginnings of Islamic Painting

♥

As one looks back at history it certainly seems surprising that Syria and Egypt fell so readily before the advance of Islam; they were both very important provinces of the great Byzantine empire, and only a few years earlier they had played an important role in bringing about the brilliant victories won by the Byzantines over the Sasanian forces in the very same area. Yet in the space of three years, between A.D. 638 and 641, the whole of the country from the fringe of the Arabian desert in the east to that of the Sahara in the west had been overrun by Islamic troops, and within only a few years more Syria had become the hub of a Moslem empire which exceeded in size that of Rome in its heyday. Perhaps the progress of Islamic conquests would not have been so easy if the Christian population of the area had not already been alienated by the findings of the great oecumenical councils held at Constantinople in 381, at Ephesus in 431, at Chalcedon in 451 and at Constantinople again in 553, where the Nestorian and Monophysite persuasions of the faith – the very branches most in favour in Syria and Egypt – were anathematized as heretical; perhaps the control of the conquered provinces would have been more difficult had not the Islamic conquerors declared a liberal policy towards the Christian sects, which was to continue over the whole Islamic world at least until the thirteenth century; perhaps the situation would have been very different if the caliph had not been wise enough to take over in Syria the very efficient civil service and mechanism of government that was already operated by a Christian personnel. These however are matters of speculation; the fact remains that affairs settled down under the Moslems to a normal and efficient running with astonishing speed; the Arab conquerors forsook their natural occupations as raiders

A

and freebooters, and their leaders had not only, within a genera-
tion, to a great extent adopted the settled life characteristic of
a province of Byzantium but had also developed a taste for
culture, and had inherited the role of the Western emperors as
patrons of art and leaders of religion. From the very first,
indeed, the duties of ruler of the state and caliph of the faith
were merged, thus following the Byzantine conception of the
emperor not only as the head of the state but also as Christ's
viceregent on earth.

Not only was the system of government and the basis of
civilized life taken over from Byzantine Syria by the Omayyad
rulers; the art of the region was adopted also, and the buildings
that were erected and the decorations that were set within them
under the patronage of the Omayyad caliphs all continued, to
some extent at least, along the lines of development normal in
a wealthy and prosperous Byzantine province. The plan and
elevation of the Dome of the Rock at Jerusalem, founded by
Abd al Malik around 692, thus represented, as Creswell has
shown, the logical line of development of the Byzantine
centralized plan as we see it in the churches of San Vitale at
Ravenna and Sts Sergius and Bacchus at Constantinople. The
Mosque of Al Aqsa, founded in 690, but extensively restored
in 746, perhaps had more local antecedents, in that it was
directly inspired by such a building as the church of the Nativity
at Bethlehem, though its capitals and cornices were wholly
Byzantine; the Great Mosque at Damascus, built under the
patronage of Al Walid between 705 and 715, was virtually a
Christian basilica, with mosaics and marble revetments on its
walls just like those of any important Byzantine structure,
though the shrine was set at the centre of the longitudinal
axis instead of in the apse, and the atrium was transferred from
the western end to the northern side.

Such prototypes as were available in Christian art exercised a
similar influence on the development of painting and mosaic.
Floor mosaics of late Roman type had for centuries been usual
in Syria and Palestine – those dating from the third and fourth
centuries at Jerash and from the second to the sixth at Antioch
may be noted in passing. Naturalistic wall paintings in the
Hellenistic style must have decorated many secular buildings;
a few still survive to this day in tomb chambers at Palmyra.

1. DAMASCUS. *The Great Mosque, c.AD 715. Mosaic*

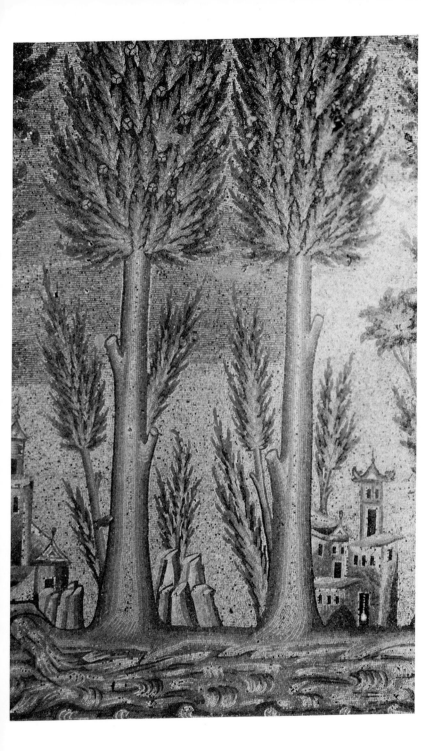

An important orientalizing school of art had been developed
early in the Christian era, as we see in the Temple of the Palmy-
rene Gods of A.D. 85 at Dura, and this had exercised a very
considerable effect on subsequent developments over the whole
nearer east, both in the Christian sphere and in Sasanian Persia.
In contrast to the local products, wall mosaics which represented
the most up-to-date developments in metropolitan Byzantine
art had, as we know from the records, been set up in the church
of the Holy Sepulchre at Jerusalem, in that of the Nativity
at Bethlehem and no doubt elsewhere, under the patronage of
the Byzantine emperors. Indeed, there was such a mass of
material available in Syria that it would have been extremely
surprising if its influence had not been widely exercised on the
developing art of the region, whatever its religious or social
complexion might have been.

Important though this Hellenistic-Byzantine tradition was,
it was not, however, the only source from which the budding
art of Islam could draw. Already, in the fifth and sixth centuries,
Sasanian elements had begun to affect the area, as we can see in
some of the mosaic pavements at Antioch, like the one from
the 'House of Beribboned Lion', as it is known. Streamers
flow out from behind the lion, and they are like those we see
associated with animals and monarchs on the Sasanian rock
reliefs and silver plates; on another of the Antioch floors the
streamers are attached to goats' heads. By the time of the Islamic
conquest these and other Sasanian elements had become
virtually an essential part of the Syrian repertory. Their
importance was no doubt intensified as a result of the fact that
the Sasanian empire was embraced within the fold of Islam at
the same time as were Syria and Palestine. In any case, purely
Sasanian motifs play an important part in many of the earliest
Islamic works; the painted panels from Qasr al-Hair or many
of the mosaics of the Dome of the Rock may serve as examples.
At a later date, when Iraq became the principal centre of Islamic
power and culture, the Sasanian elements exercised an even
greater influence. Sasanian models were available on the spot
in a way which had not been the case in Syria. A great decorative
panel in paint or mosaic in the Sasanian palace at Ctesiphon
survived at least until around 900 and, if we are to believe
the writers, it was much acclaimed in early Islamic times;

other Sasanian works were available also, and the frescoed decoration of the Djausaq palace at Samarra – fragments of which were recovered by the German excavators just before the First World War – was in a style as much, if not more, Sasanian than it was Mediterranean. The birds and animals enclosed in roundels, the figures in arcades, and certain other designs of a rather formal but vigorous type are thus wholly Sasanian. Though some writers have tended to condemn the Samarra paintings as the last gasp of a dying and outworn Hellenistic tradition, others have accorded great importance to them as the repository for a number of Sasanian elements that were later to play a leading role not only in Islamic but also in Christian art, more especially that of Armenia.

But the debts to the Hellenistic, Byzantine and Sasanian worlds were not the only ones that affected the art of Samarra, for there appear among the frescoes certain themes and elements of iconography that had their origin even further afield, in the art of Central Asia. Most important among these are certain of the poses adopted by seated figures and a number of details of costume. Thus the poses of individuals who squat either with one leg curled under the body with the other left dangling, or with both legs crossed under the figure, are of Central Asian origin, as are the long coats with double flap fronts and the leather belts with thongs hanging from them. These motifs would seem to have been first used in Central Asia, and we know of them owing to the discoveries made by Sir Aurel Stein, Von Le Coq, Grünwedel and others on the western fringes of China. Here a progressive civilization had flourished until about the ninth century when, as a result of climatic changes and the devastations of war, the water supply dried up and the whole region was deserted. The area till then had been a cross-roads of the cultures of East and West, where Sasanian elements moving eastwards met with those of Far Eastern or Indian origin; and there Nestorian Christians, Manichaeans and Buddhists all served as sponsors and patrons of the arts. Grube indeed distinguishes two separate trends of Central Asian influence in early times, one emanating from the paintings of Miran and the other from the region of Turfan.[1]

That numerous stylistic and iconographical factors which were later developed in Islamic art had their origin in this

region is not to be denied; they penetrated to the West at an early date, by way of Abbasid paintings like those of Samarra, and again later, as a result of Mongol invasions, when they influenced the miniature painters of Persia directly. There was thus, not unnaturally, a marked intrusion of Central Asian, even of Chinese, elements at the time of the Mongol conquests, and in much of the work of the early fourteenth century the Hellenistic or Byzantine heritage had been virtually eclipsed, owing to the dominance of Central Asian or Far Eastern ideas.

Apart from the various areas or cultures which contributed to the development of Islamic art and more especially the painting, a word must also be said with regard to the various ethnic elements that were embraced within the cloak of Islam, for writers in the West have often tended to become protagonists of a particular area and to assign all the glory to one group and disassociate all credit from the others. It has thus been asserted that Islamic painting was either wholly derivative or insignificant till work was developed in Persia in the early fourteenth century; some writers have thus attributed to the Persians all that is best in the field of manuscript illustration from the end of the twelfth century onwards, disregarding entirely anything that the Arabs had to give. It is literally only within the last decade that the later Turkish contributions have been acknowledged. Others again, with more justice, have preferred to regard the thirteenth-century paintings which we group broadly under the heading of the 'Mesopotamian' school as wholly the products of Arab artists, disclaiming any Persian contribution to the development of this clear-cut style. But even here there are divisions, for some would accord the glory of developing the Mesopotamian school to Iraq, while others stress the importance of Egypt, both as a precursor of the Mesopotamian school in Islamic times and as a centre of Hellenistic survivals. Others finally have, more recently, stressed the importance of the Turkish contribution in comparatively early times, not only attributing to Turkish people the elements associated above with Central Asia, but also suggesting that the whole of Islamic manuscript illumination was basically a Turkish art. Such an extreme view is untenable, even if painters of Turkish race may have been extensively employed in early times by the Manichaeans and Nestorians

in Central Asia or at a later date by the Mongols. It is not to be disputed that some of the motifs in the miniatures of the Mesopotamian school, as well as in the wall paintings of Samarra, were derived from Central Asia, but to stress the role of Turkish artists further than that would be to deny the evidence of the profound and outstanding differences that distinguish the miniatures of the so-called Mongol school after about 1300 from those of the 'Mesopotamian' school in the preceding centuries. Nor can the role of Egypt as an originator be accepted without some reservations, even if paintings of Hellenistic style were produced there in the ninth century. Painting was developed there under the Fatamids, but the inspiration came directly from Syria and ultimately from Iraq, where Sasanian elements had already been incorporated. If there was an Arab contribution, as there most certainly was, it was from Iraq that the initiative came rather than from Egypt, however important subsequent developments in that area may have been.

It will be our aim in the pages that follow not only to examine all these elements and areas, but also to estimate their relative importance even when the monuments that survive are few and far between. Our object is to study Islamic painting as a whole and to distinguish one from the other the various ethnic and local elements that went to its composition.

1 *The Classical Style in Islamic Painting*, Ed. Oriens, 1968.

2

Painting under the Omayyad Caliphs

Ψ

Though in later years Islamic painting was almost entirely an
art of the book, painting being in the main represented by
illustrations in the manuscripts, the earliest work done for
Islamic patrons was of a very different character, consisting of
wall paintings and mosaics in the buildings, all on a very large
scale. Some of these are to be found in secular constructions,
others in the mosques, and even as early as the end of the
seventh century the same divisions between secular and reli-
gious art that pertained in the manuscripts are to be seen. There
the Koranic illuminations were wholly non-representational,
whereas the secular books were adorned with the most lively
figural illustrations; in the early buildings the same was true;
in the palaces figural work of an Hellenistic type was usual,
but in the decoration of the mosques, though at times buildings
and landscapes were depicted, with great attention to natural-
istic representation, the portrayal of the living figure was
studiously avoided. The art was here a non-figural one, but not
a non-representational one in the narrower sense of the term,
as were the Koranic illuminations.

It is recorded that the caliph, Moawiya (661–680), was
responsible for several buildings, but nothing survives from
his day so that it is to one of his successors, Abd al Malik
(692–705) that we are indebted for the earliest decoration that
has come down to us; it is that of the great mosque known as the
Dome of the Rock (691) at Jerusalem. The work is in mosaic,
and covers the whole of the interior of the building; originally
there were mosaics outside also, but these have perished,
having been replaced at a late date by ceramic tiles.

The capitals, carved cornices and marble revetments of the
Dome of the Rock are essentially Byzantine and might equally

well have been set up in Constantinople; the mosaics, though they are in many respects Byzantine, also show the influence of Sasanian art, more especially in the great formal vase patterns that occupy the spandrels of the arches (Plate 2). They occupy three zones, corresponding to the divisions of the structure. First, are those in the octagon, which are dated by an inscription in Kufic to 691/92; second, are those in the circle within the octagon which are of the same style and date as those in the octagon, though there is no inscription; and thirdly there are those in the drum above, which are in two registers. An inscription records that they were restored in 1027/28, but their basic design goes back to the foundation of the building, and they conform with the other two series to form a decoration of absolute unity in spite of the very considerable diversity of actual motifs.

The basic elements of the decoration are very varied. Some of the mosaics are essentially naturalistic, like the trees, which would seem to have been inspired by close observation of local surroundings; the clusters of bamboos and some of the fruit trees are especially well done (Plate 3a). Other of the mosaics, like those depicting acanthus and vine scrolls, are more formal and belong to an old and well-established Hellenistic repertory which had been in service for many centuries, especially as parts of the borders of mosaic floors; floors at Antioch and elsewhere may be compared, but the ultimate prototypes are to be found in antique rather than in early Christian art, whereas the most striking parallels for the numerous garland motifs are to be found in the mosaics of Ravenna and Salonica. Other patterns, like the cornucopiae, vary from an elegantly formed classical cornucopia to compositions of strangely formalized shapes, which might be called decadent were they not so well proportioned and colourful; some, like the double winged motifs or some of the more stylized tree or vase forms, reproduce designs for which the most immediate models are to be found in the art of Sasanian Persia. Most effective of all, however, are the great composite motifs, where vases, baskets, flowers, pine-cones, fruit and jewels are combined together to form lovely decorative patterns. And here, though the elements are diverse, they have been fused together into a unity which represents something wholly

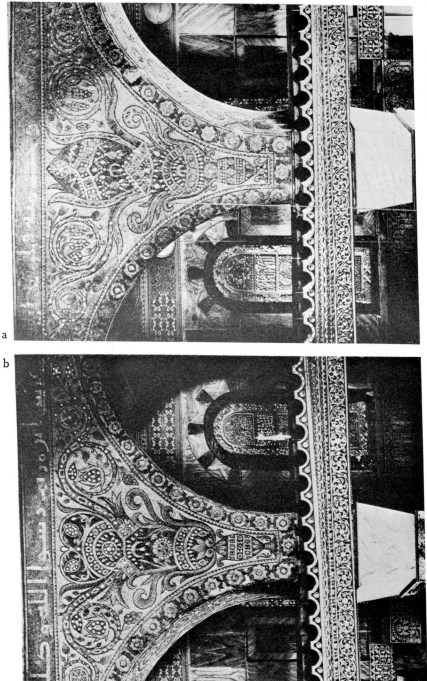

a

b

2 (a) & (b) JERUSALEM. *The Dome of the Rock,* c.AD 690. *Mosaics*

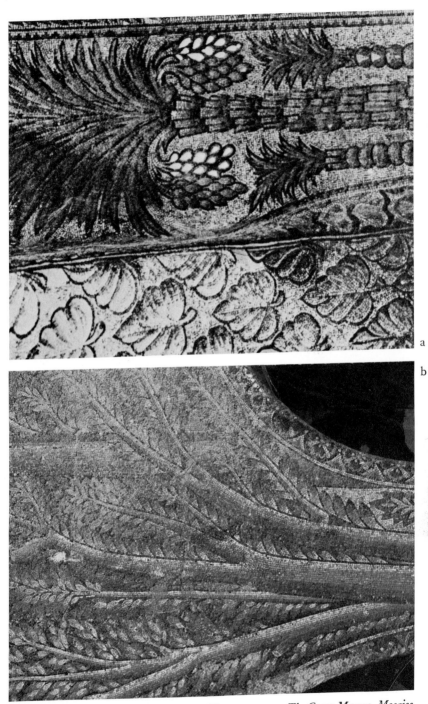

3 (a) JERUSALEM. *The Dome of the Rock.* (b) DAMASCUS. *The Great Mosque, Mosaics*

original and distinctive, and which may perhaps be accepted as the first truly Omayyad contribution to art. Though the geometric and interlacing patterns, which were later to become so essential in Islamic art, are absent, there is something here which is certainly not a part of any Christian repertory and which we would hardly expect to find even in the most oriental-izing of Byzantine decorations.

These magnificent mosaics served to inspire other work in Jerusalem at a later date, notably some mosaics in the mosque of Al Aqsa, which were set up when the building was restored by the Fatamid ruler As-Zahir in 1035. They take the form of rather stylized copies of some of the panels in the Dome of the Rock and like them they were no doubt included, on the one hand, so that the mosque should not appear to be in any way inferior to a Christian church, and, on the other, because of conservatism; old ideas die hard and it would have been unseemly that a great religious building of the new faith, where the people met to do homage to the divine power, should not be as grand and as rich as those which had been set up in the services of other faiths of an earlier age.

The Great Mosque of Damascus, completed by Al Walid about 715, is perhaps less ambitious architecturally than the Dome of the Rock, for it is a three-aisled basilica with a simple timber roof. But the scale is far greater and the mosaic decora-tion was much more extensive than was usual even under Christian patronage, except in the very grandest of churches, for the decoration extended over the walls not only of the mosque itself, but also over those of the whole forecourt, the atrium. Once more the capitals and the marble revetments follow Byzantine prototypes, and the attention lavished on these details was as great as that bestowed by any Byzantine emperor on a church built under his auspices. Indeed, its lavishness gave rise to certain criticism in subsequent years, as is recorded by Muqadassi:

'Now one day, I said, speaking to my Father's brother, O my uncle, verily it is not well of the Kaliph al Walid to expend so much of the wealth of the Moslems on the mosque at Damascus. Had he expended the same on making roads, or for caravanserais, or for the restoration of the frontier fort-

resses, it would have been more fitting and more excellent of him. But my uncle said to me in answer, O my little son thou hast not understanding! Verily al Walid was right, and he was prompted to a worthy work. For he beheld Syria to be a country that had long been occupied by the Christians, and he noted therein the beautiful churches still belonging to them, so enchantingly fair and so renowned for their splendour . . ., so he sought to build for the Moslems a mosque that should prevent their regarding these, and that should be unique and a wonder of the world.'

Rich though the architecture and marble revetments were, the most sumptuous part of the decoration is to be found in the mosaics that adorned the upper parts of the walls of the court-yard; the mosaics in the mosque itself have mostly perished, but those in the courtyard survive in greater part. If the mosaics of the Dome of the Rock set a standard in formal design, those at Damascus are unsurpassed in the whole realm of mosaic art on account of their imaginative fantasy and the sheer beauty of the compositions (Plate 1,). Their conception seems at first glance to be basically naturalistic – the trees, the villages, the houses, the river (perhaps the Barada itself?), all suggest that their creator had observed and sketched the delightful natural resources of Damascus. But it is at once obvious that the larger compositions were inspired as much by the imagination of the artist as by any imitation of nature, so that the complex forms a true work of art. Endless possibilities of exploration are suggested behind the echoing walls, empty of living persons like the deserted towns and churches of northern Syria today; the buildings themselves are redolent of all the romance of a Xanadou; it is hard to believe that even the great throne room of the Byzantine emperor Theophilus, with its mechanical throne, its golden lions that roared and birds that sang, was more fantastic, or more delightful in concep-tion.

Though the non-figural conception and the glorious fantasy of these mosaics represent something new in art, many of the basic themes have a long history behind them. The trees and plant motifs are akin to those of the Dome of the Rock, except that there are no Persian elements; both have a long line of

predecessors in Byzantine art (Plate 3b). The great architectural compositions clearly derive from Hellenistic or Byzantine models; the rock-cut façades of Petra on the one hand, the painted decorations of Pompeii or Boscoreale on the other, furnish the ultimate prototypes which were followed by the Christian mosaicists in decorations like that of around 400 in the church of St George at Salonica or in that of about 450 in the Baptistry of the Orthodox at Ravenna (Plate 4b). The naturalistic views of hill towns and villages are akin to those which were popular at Pompeii (Plate 4a). The very nature of the scheme as a whole belongs to the traditional Byzantine conception of the garden of Paradise which must have played a prominent part in early decorations; although no actual examples survive, there is a hint of what they might have been like on a fragmentary panel in the church of St Demetrius at Salonica. The Damascus mosaics thus in some ways represent the survival of a very old art; in others it is a wholly new one. But in no way is it a dead art; on the contrary, it is very fresh and alive, rising as a newly born and more glorious phoenix from the ashes of past grandeurs.

But were these past grandeurs wholly Syrian, as Miss van Berchem would have us believe?[1] The trees with their sawn-off branches, following a curious but age-old convention, appear in mosaics of earlier date all over the Roman world from Palestine to North Africa; the models for the more grandiose architectural compositions are just as much Romano-Hellenistic as Syrian; the hill-towns, rendered with so much feeling for naturalistic representation, savour strongly of Italy. And technically the work, in its surprising elaboration, is closer to that done on walls on behalf of Byzantine imperial patrons than to that on the earlier floors that we know from such Syrian sites as Antioch or Homs. At Damascus the technique is of the most delicate and the colours are unusually rich; there are four distinct shades of gold, thirteen of green, four of blue, three of silver and at least two of red, a count which is hardly equalled by even the most luxurious mosaics we know from elsewhere. If any floor mosaics are to be compared, those of the Great Palace at Constantinople spring to mind; there the cubes are equally small, the palet similarly rich and varied, whereas in the later Syrian floors the cubes are large, the work comparatively

4 (a) & (b) DAMASCUS. *The Great Mosque, c.AD 715. Mosaics*

a

b

clumsy, and the colours limited. The great perfection and elaboration we see at Damascus indeed suggests that the work can only have been done with the aid of the most fully trained craftsmen, drawn from the richest and most accomplished workshops. The tremendous accomplishment of their work is further indicated if the mosaics at Damascus are compared with later ones in the same vein in the Madrasa Zahiriya, set up by Baybars II at Damascus in 1277, which seem clumsy and careless in comparison.

The tradition that craftsmen and materials were sent by the Emperor of Byzantium to help with the construction and decoration not only of the mosque at Damascus, but with that of other of the earlier structures, is a deep-seated one. Gifts and tesserae were, it is recorded, sent to Medina and there are also accounts dating from 874, according to which the caliph Al Walid applied to the emperor of *Rum* (Byzantium) for the loan of workmen. Muqaddasi, writing around 985, refers to materials, but adds the somewhat vague statement that Al Walid gathered together workmen from Persia, India, the Maghreb and Rum. The reference to workmen from Rum was repeated in the twelfth century by Ibn Askir, as well as by other later writers who mention such astronomic numbers of men that they are hardly to be regarded as reliable.

Miss van Berchem, in her excellent publication of the mosaics, seeks to discount these references, preferring to regard the Damascus mosaics as wholly Syrian works. She suggests that as the texts are all a good deal later in date than the mosque or its decoration, they are not to be regarded as reliable, and M. Sauvaget has supported her, saying that the texts are 'legendary' and that relationships between the Omayyads and the Byzantines were not such as to permit interchanges of a cultural nature, while he thinks that *Rum* was a term applicable to the Christian world as a whole. But the more we learn of the the history of this age, the more apparent does it become that commercial and artistic contacts with the Byzantine world continued in spite of political disputes, while all the evidence goes to show that the term *Rum* was normally applied only to Europe or to Byzantium itself. Moreover Gibb, in a more recent study, supports the accuracy of the Islamic writers, stating that the tendency of the Omayyads to adopt Byzantine usages was a

patent fact: he calls attention to a text which was not known to Miss van Berchem and Sauvaget, which states that both materials and workmen were brought from Byzantium both for Damascus and for Medina.

Why a myth, attributing glory to the Christian capital, should have been coined in the ninth century, at a time when Islam was at the height of its glory under the rule of the Abbasid dynasty at Baghdad, Miss van Berchem does not attempt to explain. Surely at that date there would have been no need to attribute credit to the Byzantine emperor or to Christian workmen unless there were substantial grounds for the statement? But apart from this, a study of the mosaics themselves supports the theory of Constantinopolitan influence, for there are close technical and stylistic similarities between the Damascus compositions and the floor mosaics of the Great Palace of the Byzantine Emperors at Constantinople which was unearthed by the Walker Trust in the years just before and just after the Second World War, and which were only published after Miss van Berchem's text was written.

So far as technique is concerned, these similarities are most obvious with regard to the treatment of the trees. Both at Constantinople and at Damascus they play a vital part in the compositions and are by no means to be regarded as subsidiary to the architecture, as they usually are elsewhere. In the second, the leaves in both places – done in various shades of green – are as it were silhouetted against a sort of dark foil, executed in deep blue or black. This mannerism was universal both at Damascus and Constantinople; it was followed at times, but not universally, in the floor mosaics of Antioch, but there the majority of the trees have green foliage against a white background; indeed it was only in the later work there, like the so-called 'House of the Worcester Hunt' that any use of the dark foil was introduced. In all three places the trees follow the same basic convention with the cut-off stumps of branches prominently displayed, and with darker cubes to indicate the sides of the trunks; the setting of the leaves against a dark background must have been a late refinement, introduced in all probability from Constantinople.

The stylistic evidence is even more convincing, for everything goes to show that work in Syria became progressively

B

decadent from the sixth century onwards. The later mosaics at Antioch are extremely poor in contrast with the earlier ones, and in the other arts that we know, stone sculpture and ivory carving foremost among them, the same decline is apparent. Indeed, it is inconceivable that work of the superb quality that we see at Jerusalem and Damascus could have been produced without some assistance from outside. The texts tells us whence that assistance came, and there is no real reason to dispute their accuracy. Recent research indeed goes to show that the age between Justinian (527–65) and Iconoclasm (726) was not necessarily as barren a one at Constantinople as was at one time supposed; there are fine mosaics of the time of Justin II (565–578) in Hagia Sophia; the Great Palace floor itself may even be as late as about 600, and we know that fine silver was produced in the seventh, perhaps even in the eighth century. Indeed we must conclude that the story of art at the Byzantine capital throughout these years was in the main progressive, and that it was then that the foundations for the truly experimental and original style of the Dome of the Rock and the Great Mosque of Damascus were laid: this would surely have been impossible in Syria, a provincial area, wracked by wars and for a time under Persian occupation.

Whether or not the same craftsmen who executed the wall mosaics of the Dome of the Rock and of the Great Mosque at Damascus also worked on floor mosaics we do not know, but fine floors were certainly produced to satisfy the tastes and demands of the luxury loving Omayyad caliphs. A number were found by Hamilton at Khirbat al-Mafjar, a hunting-palace dating probably from the time of the caliph al Hisham (724–43). Most of them were of a conventional Roman type made up of geometric patterns, except for that in the apse of the audience hall, which takes on a new and typically Omayyad character. A great tree forms the basis of its composition, with below it an animal combat (Plate 5). The tree may be compared to those in the Great Mosque at Damascus, for it is done with great proficiency, and the leaves are silhouetted against a dark ground in the same way. The animals, on the other hand, are surely to be associated with an old Persian repertory. On one side of the tree we see a lion devouring a gazelle, a theme which was popular in Iran from Archaemenid times onwards; it denot-

5. KHIRBAT AL-MAFJAR. c.AD 730. *Floor mosaic*

ed the ability of an emperor to destroy his enemies and had been symbolic of imperial power for many centuries. It is significant that by this advanced date in the history of the Omayyads the caliphs had begun to look eastward, their efforts to conquer the Byzantine empire having failed; the inclusion of a Persian theme at Khirbat al-Mafjar, and again at Kusejr Amra around 735, may reflect that tendency – though the presence of Sasanian motifs at a rather earlier date in the mosaics of the Dome of the Rock must not be forgotten.

In addition to the mosaic floor there was at Khirbat al-Mafjar an extensive decoration in stucco relief and paint, the latter being used both to colour the stuccos which were used there in profusion, and as a wall decoration in itself. Here both tempera paintings and actual fresco were employed. The vestiges are unfortunately all very fragmentary, but enough survives to show that human figures were common among the paintings and that geometric and diaper patterns were also used; the latter were probably akin to those at Kusejr Amra which we shall examine below. In general, the work at Khirbat al-Mafjar was less Hellenistic and rather more Sasanian in style than that at Kusejr Amra, in spite of the fact that the two decorations must have been executed at much the same date. Indeed, the work at Khirbat al-Mafjar is not dissimilar from that done under Abbasid patronage a century or so later at Samarra in Iraq, where Sasanian or Central Asian elements were naturally more to the fore than in Syria.

Distinctive Persian elements again characterized some paintings found at Qasr al-Hair and now in the Damascus Museum; the most important of them depicts a hunting scene with a rider galloping forward, shooting his bow from the back of his horse (Plate 6). It shows hints of the old Parthian art of Syria and Mesopotamia as we know it from wall paintings and graffiti found at Dura on the middle Euphrates. But a little man with his mule, who appears below, seems to herald a manuscript illustration of the Timurid school, while the musicians at the top look back ultimately to Hellenistic art, though a more immediate parallel is offered by the decoration of a Sasanian silver plate, depicting a flute player and a gryphon, which is in the Hermitage at Leningrad; even more Sasanian are the streamers which flow in the wind behind the rider; the

famous silver plate of Chosroes II in the Bibliothèque Nationale may be compared. The painting indicates perhaps more clearly than any other Omayyad work the dual heritage from which the art drew. Fragmentary wall paintings from the same place are in a distinctly Central Asian style and have been compared by Grube to paintings from Miran, now in the Museum at Delhi.[2]

Another panel bears a circular medallion at the centre, in which is a figure of the earth-goddess holding a cloth of fruits. Above are two creatures which Sauvaget, who discovered the painting, aptly described as marine-centaurs. The figure of the goddess is surrounded by a jewelled medallion of Sasanian type, but the scrolls which fill the rectangle are basically Hellenistic. The outer border consists of a vine scroll of a type which became very popular in Islamic art and survived in the Near East for many centuries; we see it for example in the tenth-century sculptured decoration of the church of Achthamar on Lake Van. The palace of Qasr al-Hair is once again probably to be associated with the caliph Hisham, and to be dated to about 730.

Desert palaces like Qasr al-Hair were of considerable importance in the Omayyad world. The early sultans had not only adopted a settled life but had also accepted the fact that Byzantine ideas of an urban existence were a necessity if they were to establish themselves in the contemporary world on a sure footing. But the love of the old desert life did not die easily, and when occasion permitted the caliphs liked to escape eastwards to the fringe of the desert, where they could experience, if only for a brief space, a way of life which was strongly embedded in their make-up. A whole series of these desert palaces exists, the most important of which are those at Khirbat al-Mafjar, Qasr al-Hair, Qasr at-Tuba and Mshatta. The most interesting of them, so far as sculpture is concerned, is certainly Mshatta, for the frieze in low relief that decorated its façade – now at Berlin – is a work of very considerable artistic significance. It is perhaps closer in style to a painting than a sculpture, and once more the decorative scheme bears witness to the dual basis of Omayyad art. The other palaces are perhaps less impressive so far as their decoration is concerned, except for that at Kusejr Amra, which was adorned with a series of extremely interesting paintings.

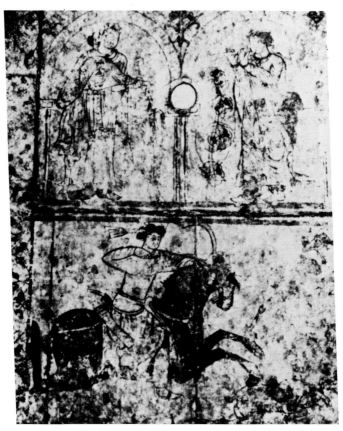

They constituted a very extensive decoration comprising scenes, figures, formal designs, and even the representation of a zodiac in a dome.

The paintings are by no means all of the same type. In a room of the bath building are figures personifying poetry, history, philosophy and so on, which are so markedly Hellenistic in style that they might well have been executed in Antioch or Alexandria five centuries earlier; they serve to show how tenacious of life the old Hellenistic traditions were (Plate 7). The ceiling decoration of another chamber, where animals and human figures on a small scale were set in lozenges to form a

6. QASR AL-HAIR. *Painting*, c.AD 730
7 (a) & (b) KUSEJR AMRA. *Wall paintings*, c.AD 724-743
(*after Musil*)

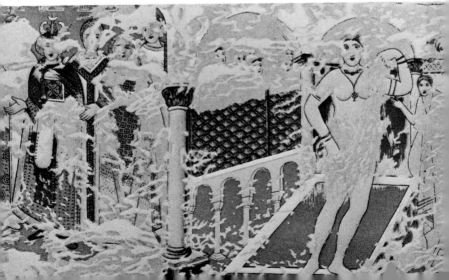

(a)

decorative repeat pattern, though somewhat more restrained, must have been similarly derived from a Hellenistic source. The drawing of the figures is conservative, but the idea of the diaper framing heralds a type of ornament that was later to become universal throughout the Islamic sphere from Spain to India and was to constitute one of the most popular patterns used for the manuscript decorations, on book bindings, and in numerous other arts. And the same may be said of the famous rendering of the zodiac, which adorns the inside of one of the domes; the theme was soon to be popularized over the whole Near East, thanks to the work of the Arab mathematicians.

(b)

Another room, which is probably to be identified as part of the harem, was adorned with figures of nude women. At first glance they too would seem to be essentially Hellenistic, but a closer study suggests that their appearance has been modified to reflect Arab ideas of female beauty as expressed in the works of the early poets of al-Hira (Plate 7c). The large breasts, slim waists and heavy buttocks all correspond with descriptions given by the poets of the ideal female figure, and it may be concluded that we are here in the presence of a work in which an old model was refurbished to suit a new conception and a new clientèle.

Even more interesting is a separate panel, done in a very different, more formal style. It depicts a group of figures, who represent the kings conquered by Islam. There are six of them; four are identified by inscriptions in both Kufic and Greek, as Roderick, king of the Visigoths in Spain, the Sasanian emperor, the Negus of Abyssinia and the Byzantine emperor; the identity of the other two, shown on a smaller scale, is uncertain; one may represent the emperor of China, while a suggestion has been put forward, though it has not been generally accepted, that the other may be a female, the Khatum of Bukhara (Plate 7b). The figures stand frontally in formal attitudes, the colours are rich and heavy and the style is distinctly Sasanian; it has even been suggested that the portrait of the Sasanian king was copied from a Persian original. No rendering of the same subject survives in Persia, but work recently discovered at Pianjkent in Tadjikistan is clearly related and serves to bear out the oriental character of the work. Another painting in the same room, alas in a very fragmentary state, appears to have been inspired by a Byzantine rendering of the Pantocrator, for it depicts an enthroned figure with a halo. It was certainly not intended to represent a divine personage, least of all a Christian one; probably it is to be regarded as complementary to the panel representing the kings; it depicts, it would seem, the victorious caliph, to whom the conquered kings render homage, not as abject vassals, but as men honourably overcome in battle who recognize the superiority of the caliph's claims.

Important though they are in the story of Near Eastern painting, however, the royal portraits at Kusejr Amra have an additional significance, for thanks to them the paintings and

indeed the whole palace – for they are clearly part of the original decoration – can be fairly exactly dated. Roderick came to power in 710 and the paintings must therefore be of later date. He was killed in the next year, 711. They must equally clearly have been done before the fall of the Omayyad dynasty in 750. The date between 842 and 856 which was proposed when the paintings were first discovered can thus be discounted. Further, one of the inscriptions – they are now almost illegible – refers to a prince, not to the caliph, as the patron, and this prince can only be either the future Al Walid II or the future Yazid III, and this being so, the most likely, indeed the only possible, dates are during the reign of Al Hisham, between 724 and 743.

Though each of the monuments of art produced under Omayyad patronage is interesting in its own way – and the mosaics of Damascus in any case constitute a work of outstanding artistic importance – it cannot be claimed that they represent anything but a very heterogeneous series, and on this evidence it is impossible to say that there was anything like a single or unified Omayyad school of painting even if, between the mid-seventh and the mid-eighth century, very considerable steps had been made in the way of creating an Arab civilization. Yet there is some sort of common denominator, other than the basic Hellenistic and Sasanian heritage, which distinguishes all these things as Islamic. 'What is it', writes Florence E. Day 'that makes Mshatta Islamic and not Ghassanid? What makes the mosaics of the Dome of the Rock Omayyad and not Syrian Christian or Byzantine?'[3] And why, one might add, are the Damascus mosaics Islamic, though on the evidence of their iconographical and technical heritage one might say that they could be classed as a characteristic work of Byzantine Iconoclasm? And what is it that distinguished Mshatta and Qasr al-Hair as Islamic palaces?

The question is not an easy one to answer in concrete terms. Old ideas were in the melting-pot; something new was in the air, and through all this work one can, in some indefinable way, sense the spirit that was later to characterize the wall paintings of Samarra in the ninth century, or the illuminations of the 'Mesopotamian' school in the thirteenth. Perhaps, if one must define it in a few words, it is the feeling for aptitude in decoration. It is this sense of fitness for purpose that distinguishes the

mosaics of the Dome of the Rock and Damascus, the carved façade of Mshatta, the wall paintings of Kusejr Amra or those at Qasr al-Hair and if in subject-matter or style there is little to bind the various paintings into a composite group or to link

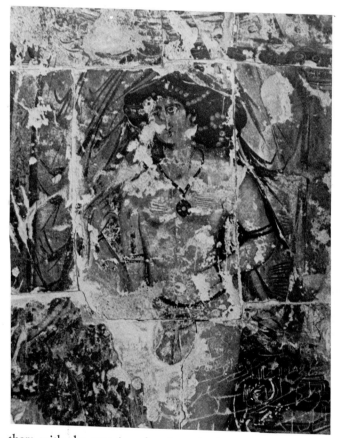

them with the mosaics, they have at least in common this factor of suitability.

[1] See her chapters in K. A. C. Creswell, *Early Muslim Architecture*.
[2] *The Classical Style in Islamic Painting*, 1968, figs. 1 and 2.
[3] In a review of A. C. Weibel's book, 'Two Thousand Years of Textiles', in *Ars Orientalis*, I, 1954, p. 239.

3

The Sasanian Legacy and the
earliest paintings in Iraq and Iran

ℭ

Though the art sponsored by the Omayyad caliphs drew in the main from the Hellenistic and Christian traditions firmly established in Syria and the Byzantine world, Sasanian elements had, as we have seen, already made themselves felt in Syria to no small degree; indeed they had even influenced the art of Byzantium itself. But when the Islamic capital was transferred from Syria to Iraq in 750 the respective importance of the roles of the Hellenistic and Sasanian traditions was reversed, and the inspiration of Sasanian art became of primary, that of Hellenistic and Christian art of secondary, importance. This was of course primarily due to the effects of locality, for Mesopotamia had throughout been one of the principal centres of Sasanian culture, and even a hundred years after the Islamic conquest a number of Sasanian buildings and works of art were still in existence; the writers speak with enthusiasm, for instance, of the Taq i Khisra at Ctesiphon and of a great panel within it, on which scenes of battle and hunting were depicted; it seems to have been done in mosaic. It has long since perished, but we can gather something of its character by comparing the low-relief rock carvings representing a great hunting scene at Taq-i-Bostan in Persia; it is usually attributed to Khosrau II (590–628) and though the building at Ctesiphon is earlier, for it was set up by Shapur I (241–72), there is reason to believe that the mosaic was later, and it too might well have been done for Khosrau II.

The Taq-i-Bostan reliefs are in an essentially painterly style and it is probable that other great decorative panels in paint or mosaic existed in addition to that at Ctesiphon. Moreover, a style proper to painting rather than to sculpture or metal-

◀ 7 (c) KUSEJR AMRA, *Wall painting*, AD 724-743

work characterizes many of the famous Sasanian silver plates, more especially those of later date; one in the Hermitage, depicting a castle being attacked by warriors may be cited; it must have been one of the models for a long series of such scenes which continued as one of the favourite subjects of representation throughout the whole of Islamic painting. It would seem that the decorations we know from several other silver plates served to inspire a number of the Samarra paintings; not only are many of the actual motifs that appear there of Sasanian origin, but also the style and colouring follow Sasanian models. There is thus a predilection for bright blues and reds, colours which were to the fore in decorative paintings of the late Sasanian or early Islamic period unearthed at Hira in central Mesopotamia, while the disposal of animals and birds in friezes or within roundels imitating jewelled bands again represents a Sasanian fashion, which we know from actual Sasanian textiles or from representations of textiles on the Sasanian rock sculptures.

Nothing remains of the earliest decorations done for Islamic patrons in Iraq. There was a famous mosque at Basra and another at Kufa, and both were apparently elaborate constructions, but we know nothing of their decorations except for the fact that mosaic tesserae were found by the writer close to the present great mosque at Kufa, which suggests that the original structure contained mosaics. Paintings also played a part in the decoration of some early Christian churches, dating from the seventh or eighth century, which have been excavated at Ctesiphon and Hira,[1] but these were restricted, and from the little that we know it would seem that the eastern Christians never favoured the lavish adornment of their buildings that pertained in the Mediterranean zone, so it may be assumed that the surge of tradition towards extensive decoration never existed in Iraq to the same degree as in the area to the West; indeed, one may assume that in Mesopotamia the predilection against figural art which had long been established in the east was a good deal more active than in Syria.

An antipathy towards the representation of living forms in art arose primarily out of the attitude taken up by Muhammad and his followers towards idolatry. Though coins bearing the portraits of rulers were accepted, it would seem that even at

a very early date figural work was eschewed by the Prophet
himself and there is a record that he ordered his wife to destroy
a hanging on which figures were depicted; she made it into
cushions and there was no objection to these because in this
way the figures were distorted and so rendered harmless.
According to another record the Archangel Gabriel failed to
visit the Prophet because there was a dog in the house and he
stated that angels could not go into a room where there was a
dog or a picture. Lammens, Creswell and others have stressed
that there was no actual proviso against representation in the
Koran and that the idea did not assume serious proportions
till the eighth century, but the evidence suggests that actually
the idea had taken firm root early in the Moslem era; but, as was
the case with strong drink, any rules that existed were not
always rigorously adhered to. The proviso must have made
itself felt in the marked distinctions that had been drawn in
Omayyad times between the aniconic decorations of the reli-
gious buildings and the figural ones in the secular structures,
and the same was no doubt true of Iraq, even probably to a more
exaggerated degree. Thus the representation of buildings, trees
and plants might well have been precluded in a mosque in
Iraq, just as any form of representation was studiously avoided
in the earliest Korans that have come down to us. The frontis-
piece of one of them, of c. 900, now in the Chester Beatty
Library, is especially interesting in this connection. It consists
of two intersecting squares set in a circle and reproduces very
closely the pattern on the title page of a famous Byzantine
manuscript of Dioscorides at Vienna, done for Juliana Anicia
in 512; there a portrait of the princess occupies the central
panel, and allegorical figures the corners; in the Islamic manu-
script there is a rosette at the centre and the corners are plain.
But in spite of such rules affecting religious art, there seems to
have been no feeling against figural work in the palaces, if the
remains excavated by Sarre and Herzfeld at Samarra are to be
taken as an indication.

Samarra became the capital in 838, selected by al-Mutasim
because his Turkish guards had taken such liberties that it had
become desirable to remove them and his court, which was
virtually under their control, from the great centre of popula-
tion that Baghdad had become. No more rewarding excavations

in the story of Islamic archaeology than those done at Samarra have so far been undertaken; nor, probably, is any other site ever likely to provide so fruitful a field, for the city was founded at one stroke of the pen and was of significance and importance for only some forty-five years, after which time it was gradually deserted. It was thus never overbuilt, burnt or destroyed. The roofs and the upper portions of the walls of its buildings simply disintegrated, being of mud or unbaked brick, and fell into the rooms they surrounded, filling them to a depth of four or five feet, and so creating a low mound which could, when the time came, be excavated without great expense or difficulty. Many of the rooms – especially those of the royal palace – had been decorated with moulded and carved stuccos; others had borne a painted decoration and when the time for excavation did come it was found that the lower portions of the walls had remained standing and that their decorations were in many cases preserved *in situ* up to a height of some five feet from the ground, while the stuccos or paintings from the upper levels were found in fragments on the floors. But whereas the stuccos were usually *in situ* and had suffered but little owing to the fact that they were situated on the lower parts of the walls, the paintings had fared less well, for not only had they been placed higher up, so that they fell to the ground, but they were also more fragile; so that most of them were in a very fragmentary state. Enough pieces were however recovered to permit a degree of reconstruction, so that the excavators were able to distinguish a considerable variety of decorative motifs and themes.

In one instance, and there may have been others, the animals – in this case camels – were in stucco relief, coloured in various shades against a bright cobalt ground so that the decoration assumed a position half-way between painting and sculpture. The camels are of the two humped, so-called 'Bactrian' variety, which probably came from Soghdia, and they thus attest links with the north and east which we will see borne out by much, but no means by all, of the rest of the decoration.

Apart from the frieze of camels which may be described as monumental, most of the work would appear to have been primarily decorative, comprising scrolls, palmettes and other motifs, ultimately derived from a classical repertory. Some of the scrolls, notably those from the Djausaq palace, were heavy

8 (a) & (b) SAMARRA. *Djausaq palace*, mid 9th cent.

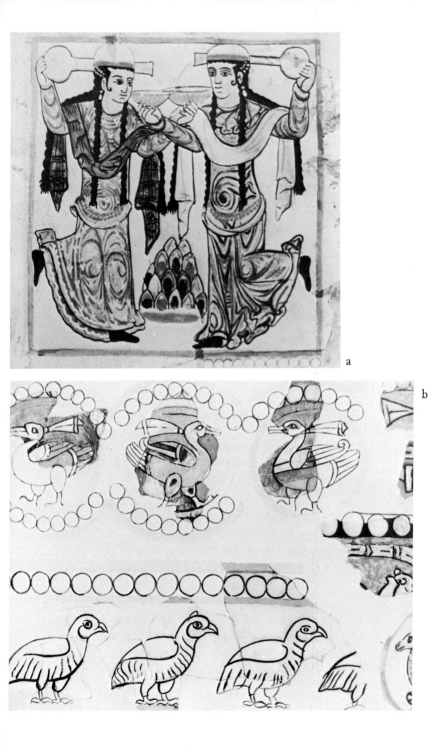

a

b

and colourful, consisting of large horns of abundance, enclosing within their curves animals, birds and even human figures. They must have been ultimately derived from classical acanthus scrolls, and Herzfeld compares them to some that appear on late classical capitals in the Museum of Antiquities at Istanbul. Though the treatment is lighter and more naturalistic, the border of the mosaic floor of the Great Palace at Constantinople provides an even closer parallel, for the scrolls there enclose birds or figural motifs which are closely similar to those at Samarra, and there are similar animals and birds in the spaces between the curves of the scroll. The idea no doubt passed to Mesopotamia, by way of Omayyad art, and the scrolls that played so important a part in the mosaics of the Dome of the Rock at Jerusalem perhaps constituted a more direct though less closely similar model. The greater degree of stylization that distinguishes the Samarra scrolls from those at Constantinople is of course to be expected in an eastern work executed some three centuries later than its Constantinopolitan predecessor.

In addition to the animals and birds that are associated with the scrolls, others are to be found in a great many more of the paintings. They appear in the borders of larger panels, within roundels, or alone, as parts of some larger compositions, and though formal and stylized, are nevertheless vivid and spirited. (Plate 8b). In most cases the models would here appear to have been Sasanian rather than Byzantine. The roundels in which they are enclosed are usually decorated with dots representing jewels, and these borders are very similar to those known on actual textiles, especially those which are to be regarded as Sasanian rather than Byzantine products; examples which are now preserved in the Musée Guimet in Paris and in the Victoria and Albert Museum in London may be compared; the example in the latter is well nigh identical with the textile represented in the rock sculpture at Taq-i-Bostan, where it actually forms part of the king's costume.

Another distinctly Sasanian feature are the streamers which fly out from the necks of some of the birds; a duck on one of the Samarra fragments may be compared to one that constitutes the main decoration of a Sasanian silver bowl in the Hermitage.

More interesting perhaps than the friezes of birds are the

compositions in which human figures play the principal part. Some of these were of an imaginary character, like the Nereids standing in water, which must have formed part of a large panel on one of the walls. They are rather heavy and clumsy and the rendering has moved very far from any classical prototype; their faces are Eastern, and the convention for the water is similar to that followed in the Sasanian rock reliefs at Taq-i-Bostan. Indeed, the Sasanian character of the whole scene is very marked. As was frequently the case in Sasanian art, all the figures were shown full-face. Fragments of other friezes representing men were also unearthed, but those depicting women were apparently more numerous. The facial types are similar to those on Sasanian sculptures, expecially those at Taq-i-Bostan, but in the Samarra paintings there are often haloes behind the heads which must be attributed to the inspiration of Christian art.

A similarly decorative character is to the fore in a series of male figures in ornate costumes which were represented as standing in arcades; they are again closely parallel to Sasanian prototypes; a silver vessel with female figures in arcades of similar form, which is now in the Hermitage, may be compared. Ultimately, a Hellenistic prototype is also possible in this case, for the arcades are not dissimilar from those we have already discussed at Kusejr Amra.

Of all the figural works, however, the most interesting are probably those, depicting dancing girls, found in the harem of the Djausaq palace (Plate 8a). They were shown in pairs with shawls behind their heads, moving in a formal, rather stately dance. They must ultimately have been derived from some Hellenistic model, for the shawls they hold belong to a very old repertory which was common in Alexandria, Syria and Constantinople in early Christian times. But this was not the only source of inspiration for the painting, for the long plaits of hair and the jewelled belts are Eastern and the facial types are Persian. The two-dimensional, decorative treatment may be compared to that on yet another Sasanian silver vase in the Hermitage. The poses of the dancers were probably customary in the Near East as a whole, as we see the theme reproduced some two centuries later on a cloisonné enamel, now in the National Museum at Budapest, done for the Byzantine emperor Constantine Monomachos (1042–55.)

C

Another interesting composition is the figure of a woman throwing down a cow – parallels elsewhere show that it is a cow and not a wild ass, as Herzfeld suggested. It is not only a spirited and vigorous piece of painting, but is also extremely interesting from the iconographical point of view, for it is a motif which recurred on numerous subsequent occasions, and even spread into the Christian world, for it is to be found as one of the themes of the sculptured decoration of the church at Achthamar, Lake Van, done for the Armenian king, Gagik, between 915 and 921. The panther in the corner of the Samarra painting belongs to the old Sasanian animal repertory, and is paralleled once more on a Sasanian silver plate in the Hermitage with a panther or leopard at its centre.[2]

Finally the figure of a man in a squatting position found in one of the houses (House XIII) may be noted. He is shown in a rectangular frame holding a drinking vessel and birds form a part of the frame. The pose is that of the enthroned figures so common in Sasanian and Bactrian art, and the Samarra rendering was probably derived from a Central Asian model.

The costumes worn by the various figures are interesting, especially in view of the actual materials depicted, for in contrast to those in the reliefs of Taq-i-Bostan, which represent the most expensive and luxurious figured silks of the Sasanian repertory, the textiles depicted at Samarra would all seem to be of a much more everyday character. The patterns are geometric and comparatively simple; there are none of the animal or figural motifs which formed the decoration of the more sumptuous silks or woollen stuffs, of which a few actual examples have come down to us from Sasanian or early Islamic times. The fragments of paintings are thus important for they represent the textiles which were in common use, and perhaps also indicate the nature of Arab as opposed to Persian tastes; in the latter region the confronted animals and similar elaborate designs seem to have remained in vogue almost till Safavid times.

The wall paintings do not represent the only form of figural painting that was in vogue at Samarra, for in addition some extremely interesting pottery vessels of large size, bearing a painted decoration on one side, were also discovered in a filling dated to the time of al Mutasim (847–59). They are in the form

of tall jars, on each of which was painted a figure about 80 cm high and 20 cm wide (Plate 9). Some of them represented priests, presumably Nestorian, some perhaps knights, and some, figures which were probably hunters. On some of them are inscriptions, one of which is in Greek. Herzfeld compared the costume of the priests to those depicted on reliefs of the fourteenth century at Mar Benham in northern Mesopotamia.

The figures of the priests follow the same convention as those of Manichaeans at Chotso in Central Asia, though they are more vivid and life-like; the hunter-portraits are more conventional – if that of a figure carrying a calf on his shoulders is to be described as a hunter – while his costume shows a mixture of Sasanian and Central Asian elements (Plate 9b). Herzfeld interpreted this figure as that of Azadeh, and the theme as an illustration of a tale in the Shah Nama, according to which Bahram Gur took his favourite, Azadeh, out hunting and in order to impress her offered to pin a gazelle's foot to its ear with an arrow. He did this by first shooting an arrow which grazed the animal's ear; it raised its hind leg to scratch the ear, and with a second arrow Bahram pinned the ear to the leg. His lady's only remark was 'practice makes perfect'. She was, it is recorded, banished for this lack of enthusiasm. Some years later the monarch visited the place where she had gone, to find a woman carrying a cow up some steps on her back. On being asked how it was done she replied, 'it is a case of practice makes perfect. I began when it was a small calf and have carried it every day since then.' It was his Azadeh who had been exiled some years before.

In a recent study of this painting Professor Otto-Dorn, formerly of Ankara University, has shown that this interpretation is probably incorrect, and suggests that the figure more probably represents a hunter or cattle-breeder. Thongs hang down from the belt at the figure's waist, and this type of belt was, she thinks, a symbol of freedom, while the thongs were marks of the clan to which the wearer belonged; both were worn by men and not by women. The theme is once again repeated in the tenth-century sculptures at Achthamar, and serves to indicate the important role that Abbasid painting must have played as a progenitor of later work over the whole

a

b

mid and nearer East; today the few fragments that remain at Samarra serve also to establish the importance of the Central Asian heritage.

The purpose and identity of these vessels for long remained a puzzle, for Herzfeld's suggestion that they were to be regarded as idols was hardly convincing, nor did his rendering of the inscriptions either as painters' signatures, or as cryptic references to Manichaeans, seem satisfactory. More recently Professor Storm Rice has offered a new explanation.[3] He read the inscriptions as referring to 'cooked wine', and cited texts in which this is mentioned; apparently 'cooked', or in Western parlance 'mulled', wine was for a time regarded as a legitimate drink in the Moslem world. He put forward evidence showing that there was a wine hall near the caliph's harem at Samarra, and he suggested that the vessels were actually wine flasks. One of the illuminations in a copy of Hariri's travels of the thirteenth century actually represents a wine booth (Paris Arabe 5847, f. 33), and there are stacks of rather similar wine vessels inside it. He suggested that the figures were perhaps vintage marks; the inclusion of priests would be explained by the fact that wine was always used by the Christians; perhaps the caliphs turned to the monasteries for the best wine just as we associate liqueurs like Benedictine or Chartreuse with the monastic orders today.

Wall paintings of a character rather similar to those of Samarra have been unearthed at two other sites of ninth-century or later date, namely Nishapur in Persia and Lashkari Bazaar in Afghanistan. An expedition sponsored by the Metropolitan Museum of New York was working for several seasons just before and early in the Second World War, at the former site. So far as paintings were concerned, the finds were very fragmentary, but traces of wall decorations were discovered in several different buildings and they included figural subjects as well as scrolls, trees and similar decorative compositions. The foliage of the trees was done in green against a deep backing, a technique which recalls that of the mosaics of Damascus, and (before them) those of the Great Palace at Constantinople. The figures in the paintings that belonged to the ninth century included a falconer with a follower in a long coat with thonged belt of Central Asian type. Many of the figures were similar to those that appear on a very important group of pottery bowls of

9 (a) & (b) SAMARRA. *Painted pottery, c.*AD 850

a very characteristic type also associated with Nishapur; a number were dug up by the American expedition, and others have found their way on to the market from numerous clandestine digs. They are usually coloured in black and green against a bright yellow ground. Their decorations serve to fill in to some extent the story of painting when work on a larger scale has perished. Other paintings from the neighbouring mound, Tepe Madraseh, which belonged to the eleventh century, were more stylized and included a good deal of purely geometric work, the patterns being rather like those of the carved stuccos of the period.

The excavations at Lashkari Bazaar were carried out by Monsieur Schlumberger for the French Institute in Afghanistan in 1950. The paintings found there were less fragmentary than any of the others, but were in a very fragile condition. They comprised a frieze of full-length figures which adorned a wall of the palace. The palace was destroyed by the Mongols in 1221, but it had been several times repaired before then, and the paintings had actually been covered over by later work. Indeed, the archaeological evidence suggested that they were to be associated with the first phase of the palace's occupation in the early eleventh century. There were no less than forty-four figures, standing with their bodies full-face, the feet sideways, and the faces in three-quarter view. There were nimbi behind the heads, and the men – probably the palace guard – wore long robes or caftans, with flap fronts, leather belts with pendant thongs, scarves and soft leather boots. The costumes thus show a mixture of Sasanian and Central Asian elements, but the haloes probably derive from Byzantine models. This mixture of influence is really not surprising in view of the locality in which the paintings were found, at the cross-roads of Asia. But the facial types are Persian, and the art is essentially a Middle Eastern rather than a Central Asian one, and is to be counted as an important piece of evidence in the story of Perso-Mesopotamian art.

[1] See O. Reuther, 'Sasanian Architecture', in A. W. Pope, *A Survey of Persian Art*, Oxford, 1938, Vol. I, p. 565.
[2] For plates and a full discussion of Sasanian metal work see A. U. Pope, *A Survey of Persian Art*, Oxford, 1938.
[3] *Arabica V*, Leiden, 1959, p. 15.

4

Early painting in
Egypt, North Africa and Spain

❦

By far the most impressive work in this area is the great mosaic mihrab at Cordova in Spain, which was added to the mosque by al-Hakim II (961–76) (Plate 10). By tradition it is attributed to workmen from Byzantium, but the floral motifs disposed like radii to the central portion are very similar to those on stucco work of much the same date in the old city of Medinet-as-Zahara not far away, while the principal element of the design is made up of three separate lines of majestic Kufic. These must have been written by a native Arabic speaker or scribe and it would seem that such a man must have drawn out the design even if the actual setting of the cubes was entrusted to a Greek. Technically the work is extremely proficient and in the grandeur of its conception, in the mastery of its design and in the beauty of its colouring the mihrab is a work of great distinction. There is, however, little that one could term Spanish or Hispano-Mauresque about it; it would not have seemed out of place in Damascus.

Thereafter there is a long gap in the story so far as Spain and North Africa are concerned, and even when it ends, with the attribution of a few manuscripts to the region in the thirteenth century, examples of works that can be assigned to the area are few and far between; the most important is a *Book of Fixed Stars* in the Vatican library (Ross, 1033), executed at Ceuta in Morocco in 1224; it is closely similar to several other manuscripts on the same subject done in Egypt and Persia. Rather later is another work containing illustrations to the story of Bayad and Rayad, also in the Vatican (Arab. 368). Broadly the style of its illustrations is akin to that of the 'Mesopotamian' school, but the colouring is less brilliant, less

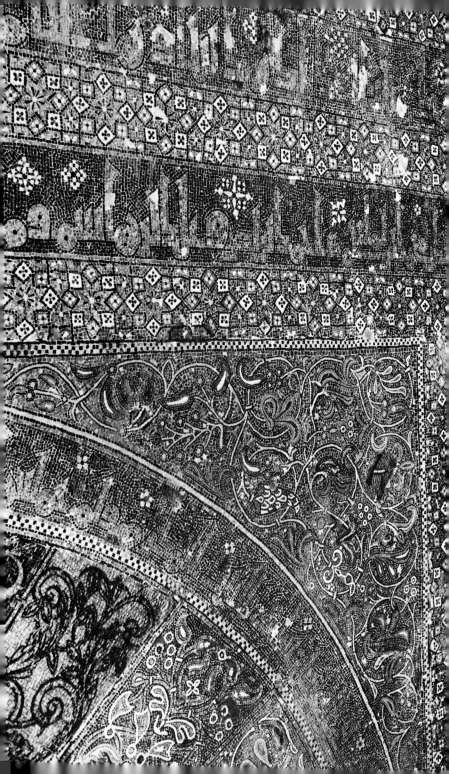

attention is paid to personality and to expression, and the decoration is more stylized. It is however a very sophisticated work, and for that reason an attribution to Spain seems more likely than one to North Africa. A Dioscorides in the British Museum (Or. 2850) is probably from the same region.

Moving eastwards, the next surviving works are to be found at Kairouan; they consist of a number of painted boards which formed the ceiling of the great mosque there; they are probably to be dated to the ninth century, for they were reused with the painted side set inwards when the mosque was re-decorated between 1020 and 1050. They bear stylized floral patterns akin to those of the mosaics of the Dome of the Rock at Jerusalem and may well have been modelled on some of the more formal of the mosaics so far as the designs are concerned. They are however much smaller in scale and the colouring is absolutely distinct, for at Kairouan it is flat, in primary shades of lemon-yellow, orange, dark and light green, bright blue and black, on a brownish ground, whereas at Jerusalem the motifs are subtly modelled with a rich gradation of tones, while the basic colours themselves are distinct, being more naturalistic and far more beautiful. The work at Kairouan in-deed would seem to have been influenced by some ancient Egyptian prototype, for the shades used on the ceiling panels are close to those which predominated on mummy cases of the later dynastic period. Fragmentary paintings on the semi-dome of the mihrab at the same place are akin and belong to a rather earlier date, There is evidence to suggest that large-scale paintings were also usual in Cairo at this period; some in the mosque of Qarafa of about 978 are referred to in the texts though nothing survives today.

The character of these paintings is very different from that of certain other important works of early date at Kairouan, notably the sculptured mimbar and the famous mihrab made up of glazed tiles; for the style of both, especially that of the tiles, is distinctly Mesopotamian, whereas there is nothing that suggests Mesopotamian influence about the ceiling paintings. The colours are indeed in marked contrast to those we know in Iraq, where the bright reds and blues which came as a legacy from Sasanian and Central Asian art seem to have continued in use for a considerable time. It is these colours

10. CORDOVA. *Mihrab in mosque, c.AD 970. Mosaic*

that predominated in the wall paintings at Samarra, and they were used too on the few pieces of painted woodwork which have been unearthed there.

As recently as 1929, when their great work on the Islamic book was published, Arnold and Grohmann wrote that there was virtually no material available from Egypt. Subsequent discoveries have, however, altered this conclusion, for, recently, a number of wall paintings of secular character have been found there, while the numerous pages of papyri that have been excavated often bear fragmentary paintings; furthermore texts frequently attest the importance that the art of painting played in Muslim Egypt over a long period of time, and a number of them refer to painting in the tenth and eleventh centuries. There is indeed an attractive story of a competition held between a Mesopotamian and an Egyptian painter, one of them doing a picture of a girl disappearing into a wall and the other one of her coming out of it. Indeed Arnold and Grohmann themselves were actually the first to call attention to the importance of the papyri of the early Islamic period, some of the most important of which are preserved in the Erzherzog Rainer Collection at Vienna. It is true that the papyri are all in very poor condition, but fragments of paintings survive on some of them and even if in their present state they are hardly to be classed as great works of art, they serve nevertheless to give an idea not only of the colouring but also of the subject-matter of these forgotten illustrations. Some consist of fairly simple line-drawings in black ink, like one published by Arnold and Grohmann depicting a bearded horseman, or another showing a dog squatting on its haunches. The way its muscles are indicated recalls some of the animal paintings at Samarra. Other fragments, in contrast, bear elaborate, fully coloured compositions, like one with a figure in the squatting position within an architectural frame; he wears a sort of crown not unlike that of the Sasanian emperors, and would appear to represent a caliph. Arnold and Grohmann suggest a date in the tenth century for this painting; the eleventh is perhaps more likely. The squatting figure is very similar to those that first appeared in Central Asian paintings, though they were copied at Samarra, and the animal recalls those of Sasanian art, so that in the case of the papyri links

with Mesopotamia would seem likely even if they are absent in the Kairouan ceiling panels. But the colours of the paintings on the papyri, where reds, greens and yellow predominate, are again characteristically Egyptian, and are distinct from those usual in Iraq or the Sasanian world, and it may be noted that, by the time with which we are concerned, the squatting pose had been more or less universally adopted over the whole Near East.

Two other drawings of early date may be noted, though they are interesting as evidence of the popularity of the art rather than because of their artistic quality, which is very poor. The first is in the Arab Museum at Cairo and represents two soldiers enclosed within a plaited border and separated by a stylized plant motif; above there is an inscription in Kufic, part of a legal text. It is to be dated to the end of the tenth or the early eleventh century. Wiet, who first published the drawing, suggests that it may have been a sketch for a ceramic decoration or a wall painting; the latter seems the more likely, for according to the records such paintings were quite usual in the eleventh century; indeed some fragments were not long ago discovered in a bath near Cairo (Plate 11a). But the head-dresses of the figures on the drawing are akin to those on pottery fragments from Fostat. The other drawing is in the Sabri collection, and represents a man who looks as if he was standing, but is actually seated. The style is not dissimilar from that of the Samarra wall paintings, and the man's costume appears to have the flap front which, in origin at any rate, stemmed from Central Asia. The drawing may well be an import from the eastern part of the Islamic world. It has been dated by Wiet to the eleventh or earlier twelfth century.

The twelfth century, happily, is a much less barren period than the centuries that preceded it. In the first place a wealth of comparable material in the form of painted glass, pottery and metal-work survives, which can be called on to complete our conception of what the larger works were like. Then there are a few small-scale works, mostly drawings, and finally there are the wall paintings. One of the most interesting of the drawings is on paper, and was found at Fostat; it is now in the British Museum; and has been published by Mr Basil Gray. It is in black, red and yellow and represents a battle

a

b

scene. Many of the warriors carry pear-shaped shields of a type used by the Normans; they were probably introduced into the Islamic world by the Crusaders, and may have come to Egypt from Palestine in the early twelfth century, or have been introduced direct from the West a little later, after the arrival of the first Crusading expedition on African soil in 1153. The round top to the shield was replaced in the West by a flat top about 1140, and the barbed lances carried by some of the figures on the drawing are of a type that was common in the West around 1130. A date after 1130 and before about 1160 seems likely. Another single leaf which was published by Wiet bears the figure of a man in a costume of Central Asian type. The style is similar to that of the dancing girls at Samarra (Plate 8a) though the drawing is to be dated to the twelfth rather than to the ninth century.

So far as Egypt is concerned the large-scale paintings of this age are represented only by a fragmentary fresco from Fostat which depicts a nude woman holding a six-stringed lute. She bears tattoo marks on her face akin to those that appear on Coptic dolls. At first glance the heavy proportions and rather gross features recall the nude figures in the bath at Kusejr Amra (p. 24), but comparisons with figures that appear on Egyptian lustre vessels of the eleventh or twelfth century support a later date for the wall painting. Dr Ettinghausen cites a bowl in the Cairo Museum, and several other examples with a similar type of decoration are preserved in the same collection. Wall paintings in some pavilions built by the sultans which are referred to in the texts were probably decorated in much the same way. This Hellenistic style was something quite distinct from the Mesopotamian, and though very few examples in the manner survive, it was probably important in secular art.

Happily, one really outstanding series of paintings of the twelfth century has been preserved virtually intact, namely the panels that occupy the ceiling of the Palatine chapel at Palermo, erected in 1144; it was damaged by fire in 1348 and restored in 1478 (Plate 11b). The ceiling is in three distinct parts, for there are flat roofs to the two side-aisles, while the roof of the main aisle consists of an elaborately sculptured vault divided into a mass of small compartments of stalactite

11 (a) CAIRO. *Wall painting*, 10th/11th cent. (b) PALERMO. *Palatine chapel*, c.AD 1144

work, in all of which there are paintings. The decoration of the side aisles is made up of a series of bands of geometric ornament, not unlike those that adorn the early Korans or the Kairouan painted panels. Each terminates at the ends in the bust of a human figure. The roof of the central aisle is more complicated, for each of the numerous compartments contains either a human figure, an animal, or a bird, while the areas in between are decorated with vegetable motifs, scrolls, fountains or similar compositions. The birds and animals belong to a repertory that is more Abbasid than Fatimid, and it owed a considerable debt to Samarra and ultimately to Sasanian Persia. The human figures however are more original, and are more akin to the Egyptian paintings noted above which were presumably common in secular buildings. Monneret de Villard, who has studied the ceiling in great detail, concludes that its paintings serve to show how close were the interchanges between the various regions of the Islamic world at the period. The paintings in the side aisles and those in the central nave have undergone a good deal of restoration, but the restorations are in a very obviously Western style and run no risk of being confused with the original painting.

It is however in the sphere of conventional manuscript illustration that some of the best Egyptian work was produced, and although it was not until the end of the thirteenth century that the style became fully mature, hints of the new developments are to be seen in illuminations done at the beginning of the century. Thus a leaf from a manuscript in the British Museum, bearing the figure of a demon – although it was later used as a charm – must have begun its career as a miniature; it is to be dated to around 1200. But that year marks something of a turning-point, for it is at that moment that the story of manuscript painting really begins, and though numerous fine examples were to be produced under the patronage of the Mamluks as the century went on, it was from Mesopotamia that the earliest books came, and it is really to the Arabs of Iraq that the credit for developing the first extensive school of Islamic secular book illustration is to be accorded. Its study will form the theme of the next chapter.

5

The Mesopotamian School

The first great school of manuscript illumination that we know was established in Mesopotamia at the end of the twelfth century of the Christian era and was responsible for the execution of a number of very distinctive and characterful illustrations, all in a broadly uniform style, which is quite unmistakable, even if there are subtle variations within its framework which are greater than those to be attributed to distinctions of hand and which should, more probably, be attributed to differences in the location of distinct groups of the school within the main area. Thus certain manuscripts can be definitely associated with Diyarbekr or other cities in the north, thanks to inscriptions; others can, on stylistic grounds, be assigned to Mosul; one was illuminated by a man of Wasit in the south, and Baghdad, Kufah and Basra have all been noted in the texts as centres where illuminations were produced, even if there are today no manuscripts in existence which can certainly, or even tentatively, be assigned to all of them. There is also a possibility that manuscripts of the same type were illuminated in Persia, and Blochet cites as the earliest example of Persian painting a copy of the *Fables of Bidpai* (*Kalila wa Dimnah*) which was done for an officer at the court of the Ghasnavid sultan, Bahram Shah, about 1150. Its miniatures are on a rather small scale, but are of quite high quality; its early date has however not been universally accepted.

Various names have been assigned to this school by the Western scholars who have studied it, some of them geographical, like 'Mesopotamian' or 'Baghdad', and some, dynastic, like 'Abbasid' or 'Seljuk'. The first is favoured by Binyon, Wilkinson and Gray; the second by de Lorey, Martin, Sakisian and Schultz; the third by Arnold and Stchoukine; and

12. SELJUK School. '*Varka and Gulshah*', 13th cent.

13 (a) MOSUL. *Syriac Gospel*, c.AD 1220. (b) BAGHDAD. '*Kitab al Baytarah*', AD 1210

the last by Kuehnel and Monneret de Villard. The term
'Baghdad' is far too narrow, for as stated above, we know that
work was done at many other places in the land of the two
rivers; if the word is to be used at all, it must be confined to
the southern branch of the school only, where the modelling
of the figures is subtle and accomplished, where the men
depicted are of very Semitic appearance, with hooked noses,
and where the understanding is lyrical rather than realist.
'Abbasid' is equally unsatisfactory, for even if work was done
during the Abbasid caliphate and even if the style of the work
is broadly akin to what we know of Abbasid art at Samarra
and elsewhere, the Abbasid caliphs had already fallen under
the domination of the Seljuks by the time the manuscripts
were produced, and they had ceased to exercise effective con-
trol some time before the manuscripts were illustrated.

In this respect 'Seljuk' is more correct, for the Seljuks con-
quered Baghdad in 1120 and from there ruled Iraq and Iran till
the time of the Mongol invasions soon after the middle of the
thirteenth century. But the style of most of the paintings is
not truly 'Seljuk'. We can, on the basis of the works that the
Seljuks sponsored in Persia and later in Turkey, associate
with them a very definite style, which is clearly illustrated on
a number of surviving works, notably a piece of lustre pottery
in the Victoria and Albert Museum, which is to be dated to
the late twelfth century, or the illustrations of the manuscript
entitled Varka and Gulshah which is now at Istanbul (Top
Kapi, Hazine 841; Plate 12) its text is in Persian, but the
style of its miniatures should be termed Seljuk rather than
Turkish, as Aslan Arpa has claimed, for Turkish is far too
indefinite a term and the word would be best retained to define
the art sponsored by the Ottomans from the end of the
fifteenth century onwards. The Seljuk style as we see it on the
pottery and in these miniatures is something quite distinctive.
The faces are broad with very small eyes, nose and mouth, the
figures are rather solid, with square bodies, and the costumes
are of a rather oriental type. All these features are illustrated
to the full in a rendering of Constantine and Helen in a Syriac
Gospel in the Vatican which was written and illustrated in the
region of Mosul around 1220 (Vat. Syr. 559; Plate 13a). The
two saintly figures wear Eastern costumes, and crowns of a

type which was brought into favour by the Seljuks. The helmets with pointed tops and neck guards hanging down behind, which are worn by the guards in the Crucifixion scene in the same manuscript, are also wholly Seljuk in style.

These features are all distinct from those in work of the Mesopotamian school as a whole, where the turban is the usual form of head-dress, and the facial types are more Semitic, as a comparison of the rendering of Constantine and Helen in the Vatican manuscript with the illustrations of any of the famous Hariri manuscripts in the Bibliothèque Nationale – which will be studied below – will serve to show. In fact the term 'Seljuk', though applicable perhaps to particular workshops which flourished under royal patronage at the capital, is not suitable as a designation for the school as a whole.

The term 'Mesopotamian' on the other hand, is far more satisfactory, especially if the geographical connotation of the term is extended more widely than is usual today so that it includes the region well to the north and west of the frontiers of present-day Iraq. In this wider sense the area includes not only such places as Basra, Baghdad and Mosul, but also cities like Diyarbekr and Mardin, which were important centres of painting, even though they lie within the frontiers of present-day Turkey. And at a slight stretch even Aleppo might be accepted as being within the geographical bounds of the area. Indeed, in the first phase of the school's existence, some of its more important manuscripts were in all probability produced in this northern region, for one of them is associated with Mardin in its colophon, while a manuscript now in the Bibliothèque Nationale (Pers. 899), which bears a dedication to the Seljuk sultan, Kai Khosrau III, appears to have been produced in Cappadocia. Another important book, the famous treatise on Automata of al Jaziri, was first written and illustrated at Diyarbekr in 1181, and the original served as a prototype for several later copies; one, dated 1206, which was also probably done at Diyarbekr, is now in Istanbul (Top Kapi Ahmet III, 3742; Plate 14) and there are several copies of the early fourteenth century, which are to be assigned to the Mamluk school.

The types of book that were illustrated by the artists of the Mesopotamian school are comparatively limited; they com-

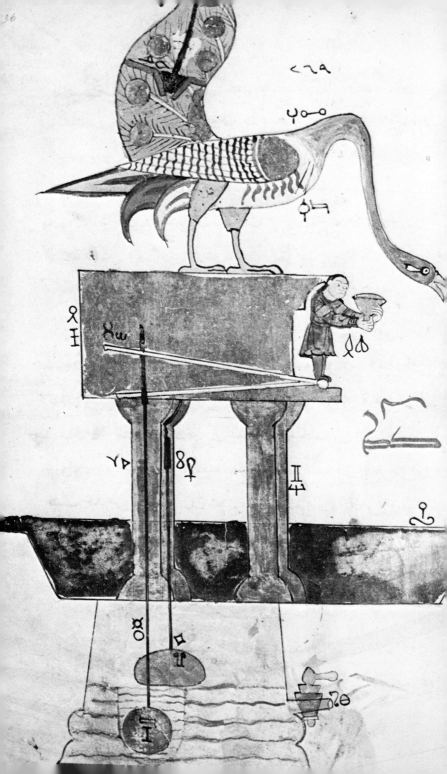

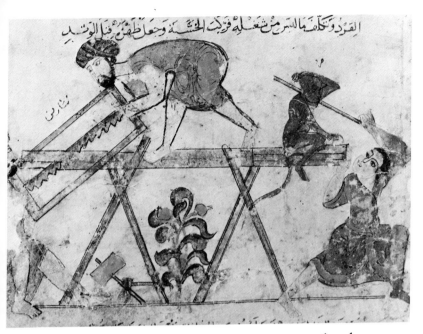

القرود و تكلمها بالسر من شعلة فركب الخشبة وجعل ظفرهن فيل الوند

prise, in addition to the treatise on Automata mentioned above, the medical works of Dioscorides and Galen, several books about precious stones or animals, like the famous *Kitab al Baytarah* – a treatise on horsemanship – the *Fables of Bidpai* (*Kalila wa Dimna*), a few volumes of lyrical poetry, like the *Kitab al Aghani* or *Book of Songs*, and perhaps most important of all, the satirical account of the travels of an engaging rascal in the Hariri manuscripts; indeed it is in the spirited illustrations to the latter that the true genius of the school probably found its most complete expression. Before discussing the enchanting Hariri illustrations, however, something may be said of some of the other books, first of all the *Kitab al Baytarah*, the treatise on horsemanship.

The two most important copies of this work that we know were both probably done at Baghdad, and they enable us to establish a clear conception of what elements are to be associated with the Baghdad branch of the Mesopotamian school. One of them is now preserved at Cairo (Khalil Agha no. 8f) and is dated to 1209, and the other, written by the same scribe,

14. DIYARBEKR. '*Treatise on Automata*', al Jaẓiri, AD 1206
15. BAGHDAD. '*Kalila wa Dimna*' (*Fables of Bidpai*), c.AD 1220

is at Istanbul (Top Kapi, Ahmet III, no. 2115) and is dated to
1210 (Plate 13b); both were copied by a certain Ali-ibn
Hassan ibn al Hibbat Allah. A third copy, now in the Süley-
maniye library at Istanbul (Fatih, no. 3609) is rather more
Byzantine in style and in Holter's view belongs to no very
obvious group (Holter 21). A fourth manuscript in the Aya
Sofya library (no. 4197) has a text which was written in
Egypt, though Holter believes that the miniatures, of which
there are nineteen, were done either at Mosul or Baghdad. All
of them must have been inspired by a lost Byzantine model.

The style of the first two manuscripts is identical and is to
be regarded as typical of the earlier work done at Baghdad.
There are no backgrounds, and the figures are as it were
treated as silhouettes; the ground, where it is included at all, is
shown as a single plane, without any attempt to indicate
depth; the costumes are broadly monochrome, without much
attempt to depict the folds or to reproduce the patterns of the
stuffs from which the costumes were made; the figures usually
wear turbans, but there are often gold haloes of Byzantine
type behind the heads. The faces are of an Eastern, broadly a
Mongol character, and are not dissimilar from those of Seljuk
type which we attempted to distinguish above. Throughout,
the figures are well proportioned, there is great life and move-
ment, and a happy sense of simple composition. The colouring
too is simple, without great gradation of tone, but it is always
bright and pleasing.

Another interesting early book is the *Manafi al Ahjar*, on
the properties of stones. Mr Basil Gray has noted a copy in
Arabic in the Gazdar collection which bears the date 1026, but
this is probably to be regarded as the date of the original
manuscript from which the surviving example was copied,
and the volume itself is probably not to be dated before the
twelfth century. There is another manuscript not unlike it at
Meshed. It is hard to say where these were executed, though
another important early manuscript may on the other hand be
assigned to Baghdad; it is an enchanting copy of the fables
of Bidpai (*Kalila wa Dimna*) in the Bibliothèque Nationale
(Arabe 3465), which is to be dated to between 1200 and 1220.
It contains ninety-two miniatures; some of them have been
retouched, though all were probably originally done by the

same hand, with the possible exception of a few at the end. All are in what may be termed the silhouette treatment, without backgrounds, and though highly stylized, they show considerable powers in the observation and interpretation of nature. A few depict scenes of everyday life, like that on f. 47 where sawyers are shown at work while a boy plays with a monkey (Plate 15). The majority of the miniatures are however devoted to animals; on f. 108v there is a picture of a monkey riding on a serpent in the midst of a landscape of strange flowering trees (Plate 16a), while on f. 87v the King of the Crows drops a rat from its beak to a tortoise waiting in a pool below (Plate 16b). The strange, partly naturalistic, partly imaginative trees are particularly delightful.

Even if he was not always able to record his visual observations very truly, the artist could interpret nature most effectively and his outlook was very original. The colouring is fresh and it is perhaps because of this that Holter (no. 26) has suggested that the manuscript should perhaps be assigned to Mamluk Egypt. This however is unlikely and a comparison with work that is undoubtedly to be counted as Mamluk, for instance another copy of the same book, also in Paris (Arabe 3467; see p. 78) shows the differences very clearly. The colours of the Mamluk example are brighter and gayer, the style more linear, one might even say more wooden, though the powers of characterization shown in the animals is no less striking. Ettinghausen has suggested that the earlier volume was produced in Syria; good work was certainly done there at an early date, but in this case the originality of the style and the degree of characterization savour more of southern Mesopotamia, and Baghdad would seem to be a more likely home for the manuscript. A later copy, now at Oxford (Bodleian Library, Pococke 400), is on the other hand more probably Syrian; it is dated to 1354; like the second copy in the Bibliothèque Nationale, it is a work of the Mamluk school.

Distinct again is another copy of Bidpai's fables with text in Persian, which is now divided between various collections; it is dated to 1236. A miniature from it depicting a camel being devoured by lions is now in the Museum of Art at Worcester (Mass.); Holter (no. 19) puts forward a suggestion that it may be Indian, but this seems very unlikely; firstly no Indian work

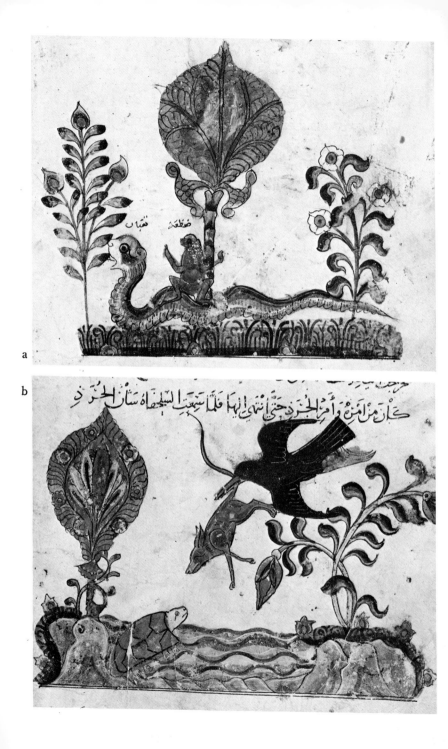

a

b

كان من آمن وأمر الجرذ حتى أنهى إليها فلما سمعت السلحفاة سار الجرذ

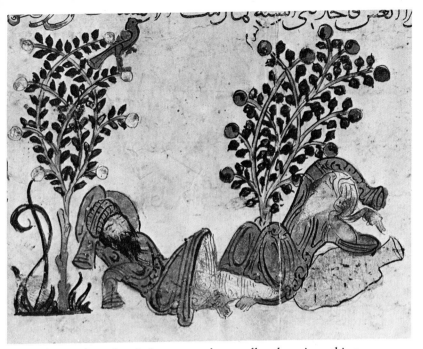

of so early a date is known, and secondly, there is nothing Indian about the style. If Sakisian is right in assigning to eastern Persia a group of paintings in a rather light, delicate style now bound up in albums at Istanbul, it would seem possible that this Bidpai was done in the same area; but Sakisian's miniatures must be at least a century later than the date he proposes. In the case of the Bidpai a Persian provenance is possible and it may be suggested that we should regard it as a herald of the lighter, more linear style which was to be developed in Persia early in the fourteenth century, primarily as the result of the intrusion of Far Eastern influences.

If the books on horsemanship and the Paris Bidpai are to be regarded as representative of the school of Baghdad, the illustrations of certain other manuscripts, though they are closely related, are nevertheless sufficiently distinct to suggest that they should be assigned to some other area within the confines of Mesopotamia. There is thus rather less feeling for modelling in the depiction of the costumes, and greater attention is paid to pattern for its own sake. The love of pattern manifests itself both directly, in the actual designs on the

16 (a) & (b) BAGHDAD. 'Kalila wa Dimna' (Fables of Bidpai), c.AD 1220
17. MOSUL. 'Travels of Hariri' (St Vaast), 13th cent.

textiles used for the costumes that the figures depicted wear, and indirectly, in the stylized, pattern-making manner in which the folds are rendered, as well as in the almost abstract way in which the pictures were often actually conceived.

That the manuscripts which show these features are to be associated with the north of Iraq is suggested by comparing them with two Syriac Gospel books, one in the Vatican (Syr. 559) and the other in the British Museum (Syr. 7170), both of which were executed in the Mosul region around 1220. Jerphanion and Arnold have both drawn attention to the close parallels that link these manuscripts to copies of Hariri's travels in the Bibliothèque Nationale, more especially to the one of the second quarter of the thirteenth century which is known as the St Vaast Hariri (Arabe 3929), and another in the same library which is fairly closely akin to it (Arabe 6094) and which is dated 1222.

The date of the St Vaast volume has been disputed. Blochet thought that it was the earliest of these Hariris and assigned it to the very beginning of the thirteenth century or even to the end of the twelfth; more recently it has been dated to the second quarter of the thirteenth. It contains seventy-seven miniatures, many of which have been much retouched, but three different hands are nevertheless to be distinguished. The figures are all vivid and expressive and show the same spontaneity as those of the Bidpai, but the costumes are more elaborate and show the interest in pattern for its own sake which can probably be regarded as a characteristic of Mosul work. Nearly all the figures have gold haloes of Byzantine type, and the features are often close to those of the Syriac manuscripts noted above, but there are no backgrounds and the ground itself is seldom indicated by more than an occasional plant, the figures being virtually silhouettes. They have indeed almost the appearance of the cut-out figures used for a Turkish shadow play (Plate 17). The faces have not been seriously damaged by the repaintings, though this has in many places affected the rendering of the costumes; in such cases the repaintings sometimes tend to mar the patterns that adorned the textiles represented; these patterns were treated by the artist for their own sakes, in accordance with the tastes that appear to have prevailed in the north (Plate 18).

The next of the Hariris, also in the Bibliothèque Nationale (Arabe 6094), is dated to 1222/23, and contains thirty-nine miniatures. Its illuminations are not as good as those of the St Vaast Hariri and the work is somewhat crude though vigorous. The faces have all been repainted and some of the figures also (Plate 19). The miniatures show some relationship to the two Syriac Gospel books mentioned above, except that the haloes of Christian type which were used indiscriminately for almost all the figures in the St Vaast Hariri are absent. There are however stylistic elements which suggest relationships with the Byzantine world and parallels with such Constantinopolitan manuscripts as the ninth-century Homilies of Gregory Nazianzus in the Bibliothèque Nationale (Gr. 510) or a fine Gospel book in the Vatican (Gr. 699) have been noted. Holter has suggested Damascus as the home of this manuscript on the grounds of the Christian elements in its miniatures, but Mosul would on the whole seem more likely; in any case it must belong to the northern rather than to the Baghdad group, if only because of similarities to the two Syriac manuscripts mentioned above which were, we know, done in or near Mosul.

The finest of all the copies of Hariri's travels that have come down to us is on the other hand to be firmly assigned to the south of Mesopotamia, owing to an inscription which states that it was illustrated by a certain Yahya ibn Mahmoud al Wasiti. It is dated to 1237, is now in the Bibliothèque Nationale (Arabe 5847) and is known as the Schefer Hariri. Wasit now stands deserted to the east of the Tigris, about half-way between Baghdad and Basra; founded probably in 703, it was a considerable city at the time that the book was produced, and it remained important till the fifteenth century. It is probable that the book was actually written and illustrated there, though the possibility that its painter was called to the capital at Baghdad to work for the caliph himself cannot be excluded. In any case there is no reason to connect the illustrations with the north or with any centre other than Baghdad or Wasit. The volume contains ninety-nine miniatures, and the work is of exceptionally high quality, the figures being expressive, the grouping effective and the colours wholly delightful. Ettinghausen reproduces three particularly attrac-

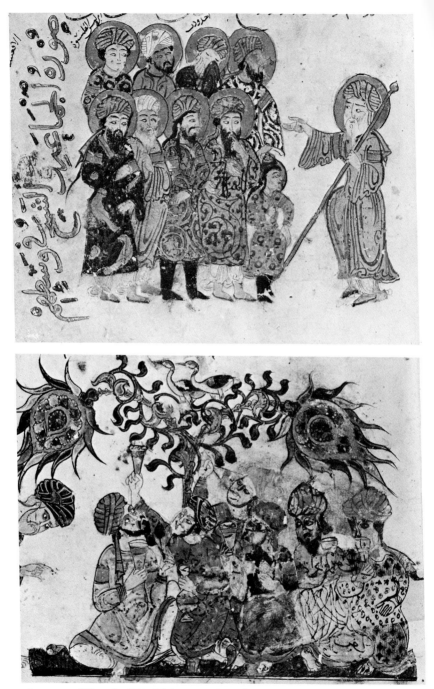

18. MOSUL. *'Travels of Hariri'* (*St Vaast*), 13th cent.

19. MOSUL. *'Travels of Hariri'*, AD 1222

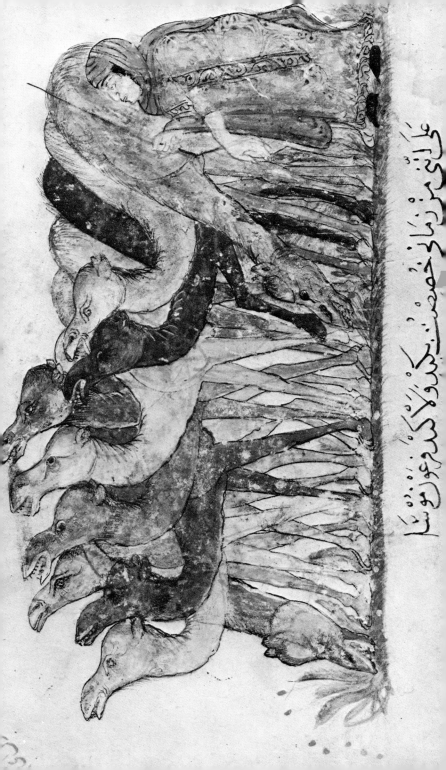

tive compositions, showing two travellers in discussion near a village, the start of a caravan and a group of horsemen waiting to participate in a parade; all are characterized by the movement, drama and vivid action of the scenes depicted, and show an ability to interpret the spirit of the scene which has seldom been surpassed. Indeed, this power of entering into the atmosphere, into the very soul of the subject depicted, was something which not only characterized the school as a whole, but also reached its height in the work of the artist responsible for this volume. A scene where a number of camels are shown under the care of their woman drover is particularly expressive (Plate 20); it is a lovely piece of rhythmic composition; even more than that, it makes a very profound picture, once more illustrating the element of 'empathy' that characterizes so much of the work of this school. This is something that has often been sought in the art of recent times; seldom has it been more successfully realized than some 750 years ago in Iraq.

The miniatures in this book differ from those associated with the north of Mesopotamia in that the costumes are in the main solid and well modelled; there is a real feeling for plasticity, which contrasts with the interest shown in pattern which dominated in the north, while haloes, so often present there, are absent. But on the other hand, the faces are very Semitic and are similar to those in the two Syriac Gospel books mentioned above; one might even go so far as to suggest that the head of Caiaphas in the scene of Our Lord's trial in the British Museum volume (Add. 7170) might have been executed by the same hand as that of Abu Zayd in the scene where he tries to sell his son to al Harith in the Hariri (Plate 21). But not all the faces in the Schefer Hariri are Semitic; some are of the type we distinguished above as Seljuk and others have slit eyes and are distinctly central Asian, even Far Eastern; the artist seems to have observed and drawn from a wide variety of facial types. The Persian or Seljuk elements are to the fore in the delightful pictures entitled 'The Eastern Isles', notably in the rendering of the human heads of the bird and beast. This is one of the most decorative and enchanting of all the paintings of the Mesopotamian School (Plate 22).

Another copy of Hariri's travels, in the Asiatic Museum at Leningrad (S.23), had remained little known and was curiously

20 (overleaf). WASIT *Travels of Hariri* (Schefer), AD 1237

underestimated till a number of excellent plates of its minia-
tures were included in Dr Ettinghausen's book on Arab paint-
ing. It is perhaps to be dated a little earlier than the 'Schefer'
Hariri, though it too must have been done in the south, pro-
bably at Baghdad. The scene where Abu Zayd presents his
case to a disdainful judge at Sanaa in the Yemen is a brilliant
piece of characterization (Plate 23a), while that where he is
taken aboard a ship is a vivid and delightful composition. Once
more the resemblance to the illuminations of the Syriac
Gospel books is very marked; the figure of Caiaphas in the
scene of Christ's trial on f. 145 in the British Museum volume
(Add. 7170) may be compared (Plate 23b). Often the faces in
these books have been obliterated by fanatical Puritans, as is
the case in a related copy in Istanbul (Süleymaniye, Essad
Effendi 2916) which dates from around 1250; in the Leningrad
book they have been made harmless by drawing a line across
the necks – an indirect way of indicating that the persons were
dead, so coping with the feeling against the representation of
living beings.

Another fine book which is to be assigned to Baghdad on
the basis of the colophon is the *Epistles of the Brethren of
Sincerity*, a sect which was founded around 970 and had for a
time quite a number of followers; it dates from 1287, and is
now at Istanbul (Süleymaniye, Essad Effendi 3638). A minia-
ture representing the authors is reproduced by Ettinghausen,
and he describes it as a 'pure example of the Baghdad School'
but it is hard to agree with this if the Schefer and Leningrad
Hariris are to be taken as the key manuscripts of the Baghdad
style. The knotted curtains, the haloes, and the treatment of
the costumes in this book clearly go back to Byzantine proto-
types (Plate 24); the colouring is distinctive and suggests
Eastern affinities, and the harsh gold lines on the costumes are
almost like the partitions of a cloisonné enamel; the well-
known Ortokid enamel dish now at Innsbrück may be com-
pared. The book is however of later date than the others and is
perhaps to be taken as representing the Baghdad style as it
developed after the Mongol conquest of 1250.

Though the two copies of Hariri's travels produced in the
north contain a number of miniatures where the stress on
rhythmical pattern that characterized the region is obvious,

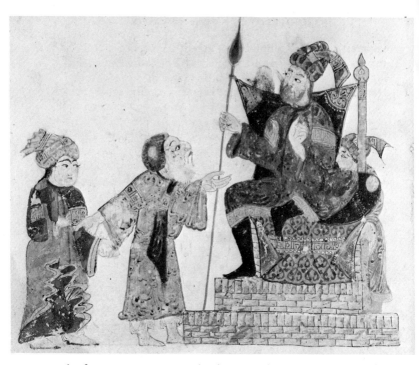

the feature is even more clearly marked in the miniatures of a
book called the *Kitab al Aghani* or *Book of Songs*. It was origi-
nally written at Baghdad in the tenth century but the oldest
copy that survives is dated 1217. It was in twenty volumes,
six of which are now preserved; volumes II, IV and IX are in
Cairo (Adab 579), volumes XVII and XIX are at Istanbul
(Millet Kütüphanesi, Feyzullah Effendi 1566 and 1565) and
volume XX is in the Royal Library at Copenhagen (Ar. 168).
Each volume contains a very impressive and remarkable full-
page frontispiece (Colour Plate 1). A few odd volumes of later
copies are also known, and they serve to complete the book
from the literary point of view.[1]

Five of the six frontispieces are portraits, and there has been
some dispute as to the identity of the figures they represent,
Professor Storm Rice holding that they are all portraits of
Sultan Badr ed Din Lulu of Mosul, for whom he thinks the
book was done, while Dr Bishr Fares associates each with
the text which follows and regards them as somewhat
idealized illustrations; the inscriptions that accompany each

21. WASIT. *'Travels of Hariri'* (Schefer), AD 1237

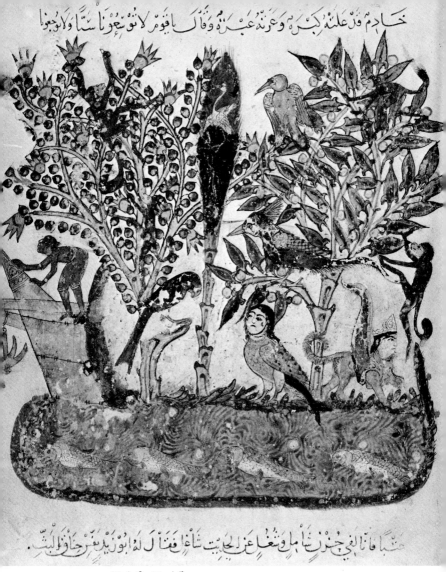

فلما فانا البي جزن ثاما وشغل عن الحبيب ثاغا فقنا له ابوزيد بفخر حاقول البشر.

22. BAGHDAD. *'Schefer Hariri'*, AD 1237.

miniature, he believes, give the title of each subject. The majestic appearance of the main personage, who is in every case shown on a much larger scale than the other figures, the similarity of his features in all the illustrations, and the obvious attempt to convey dignity and importance, however, tend to support Professor Storm Rice's identification. This is especially noticeable with regard to the frontispiece to volume XVII, where the central figure is especially dignified, his importance being indicated by a flame halo behind his head; he holds a bow in his right and an arrow in his left, both of which Professor Storm Rice regards as symbols of power. Fares' identification of the portrait as that of a famous singer is hardly convincing.

The frontispiece to volume IV depicts a very similar figure, also with flame halo, but he holds a cup in his left hand and a kerchief in his right; below on a separate register there is a group of musicians. The text is concerned with the life of a famous musician called Tuways and Bishr Fares believes that it is he that is depicted; it seems more likely that it is the emir, this time shown in a relaxed attitude, inspired by the music of Tuways.

The frontispiece to volume XIX, at Istanbul, and the one to volume XX at Copenhagen are rather similar, in that on both the principal figure is shown mounted. On the former there are three men with swords behind him and others in front, one carrying a sack, and there is a row of smaller persons in front. On the evidence of these, Fares identifies the picture as a representation of a certain Ta'abatta Sharran, a legendary figure of pre-Islamic times. On the Copenhagen picture the principal figure rides forward, a falcon on his arm; Fares identifies him on the basis of the text as a pre-Islamic character, An Namir. It may be that these associations were intended, but in spite of the fact that there is no mention of the Sultan Badr ed Din Lulu in the colophon, the central figure is again probably to be taken as his portrait.

The frontispiece to volume IX, at Cairo, presents a more serious problem. It depicts the same principal figure enthroned, with two others approaching, the foremost in black robes, and that behind in a red robe with scroll pattern in gold and blue. Two genii above hold a shawl over the head of the central

1. Frontispiece. '*Kitab al Aghani*', AD 1217. See p. 64

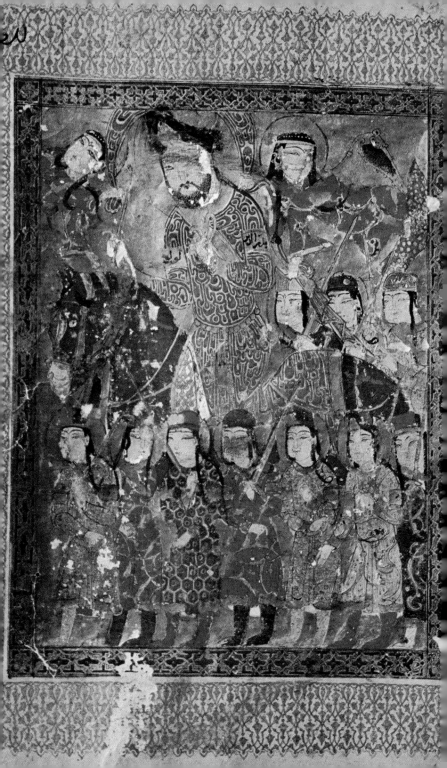

figure, and he also has an oval nimbus suggestive of a Central Asian model; the other two figures have circular haloes of a Byzantine type. The central figure was identified by Bishr Fares as the Prophet Mohammad and those before him respectively as the Bishop and Prefect of Najran; he believed that the scene recorded the Mufahala, when a treaty was made in A.D. 631 between the Muslims and Christians of Najran which was to culminate in a challenge of reciprocal imprecation. Such an identification seems to be supported by the text of the previous section. Professor D. S. Rice, however, holds that there is reason to doubt this identification, and to regard the central figure as yet another portrait of Badr ed Din Lulu. Indeed he reads the inscription on the sleeve as giving that name, but Fares takes it to be the name of the painter. If Fares is correct, this would be the earliest representation of the Prophet in existence – the next earliest that survives is contained in a copy of al Biruni's chronology at Edinburgh, which is in a similar style; it is dated 1307, (see p. 83). In this case there is much to be said for Fares' identification, especially if that of the frontispiece to volume III (see below) is accepted, though the similarity of the principal figure to that in all the other volumes is striking.

The frontispiece to the last volume to be considered, volume 11, also in Cairo, is distinct, for it represents a group of people, all of them females. Above there are six, playing musical instruments, below in the centre is a water-wheel with figures beside it bathing, and in the centre are dancers, with more musicians at the sides. The two central figures recall those of dancers in the Samarra wall paintings. One of the women wears a cross and the text refers to the story of an Arab poet who married Hind, a Christian princess of Hira; on her husband's death she founded a convent there. Fares suggests that the scene depicts ritual dances of the nuns in the convent. If he is correct, the picture is especially important, as indicating the close association between Moslems and Christians at the time. Similarly in the Syriac Gospel books there are sometimes included groups of veiled women of a wholly Islamic character. When considered in conjunction with the stylistic similarities that bind the Islamic books to the Syriac Gospels, one might even conclude that the same painters

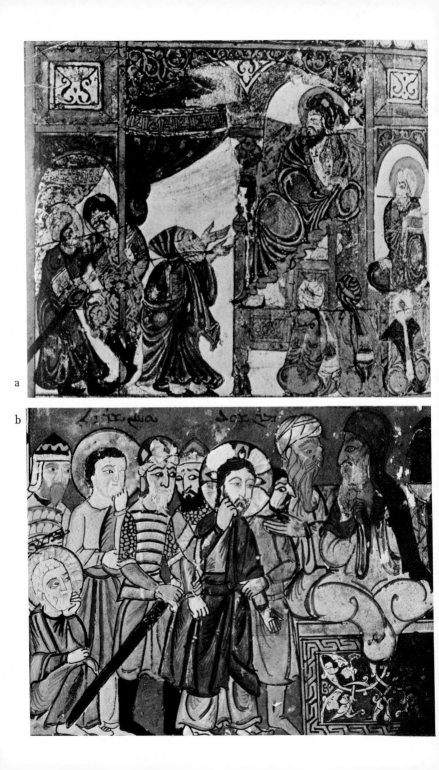

a

b

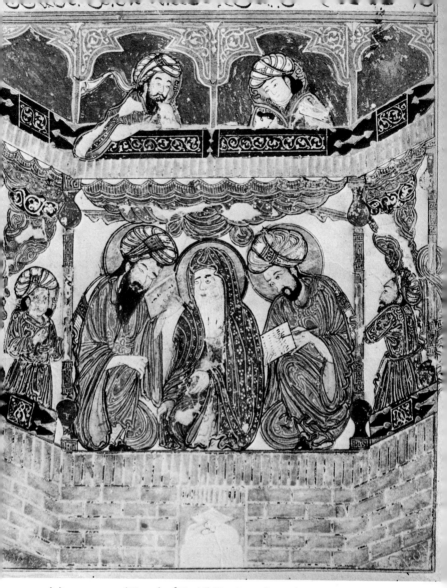

23 (a) BAGHDAD. '*Travels of Hariri*' (Leningrad, s. 23),
c. AD 1230. (b) Syriac Gospels, *c.* AD 1220 (B.M. Add. 7170)

24. BAGHDAD. '*Epistles of the Brethren of Sincerity*', AD 1287

worked indiscriminately for Christian and Muslim patrons alike. The general style of the work, however, supports Bishr Fares' contention that all these paintings are to be regarded as the work of Arab artists, even if there are certain Persian or Central Asian details, notably the fur hats and soft boots worn by some of the figures.

The illustrations of a number of medical treatises are in a style close to that of the Aghani miniatures, and must also probably be assigned to Mosul or its neighbourhood. First may be mentioned a Theriaca or pseudo-Galen recently discovered by Dr Bishr Fares in the Bibliothèque Nationale (Arabe 2964, formerly 2433). It was copied for a certain Mohammad and is dated 1199, but the colophon which gives this information does not state where the work was done. Fares has assigned it to Syria, but once more Mosul would seem more likely, for as he has shown, there are elements in the composition of the title page, such as the crescent which surrounds the central figure and the serpents framing the composition, which are to be associated with the old Mesopotamian cosmogony and which appear in Mesopotamian art throughout the ages; the serpents indeed are closely akin to those which decorated the lovely Talisman Gate at Baghdad, dated to 1221; it was alas destroyed in 1917. The figures that appear at the centres of the double title page, however, are rather suggestive of Boddishatvas, and combined with the red ground against which they are displayed, serve to recall the paintings of Central Asia. Some of the scenes that illustrate the text are less monumental, but are vivid and expressive and approach closely to the style of the Schefer Hariri. One with agricultural labourers engaged on the cultivation of medicinal plants may be cited (Plate 25); the trees follow the usual stylization, and the figures all have haloes; the physical types however are less Semitic than in the early Hariri manuscripts and are less closely related to those in the Syriac Gospels in the British Museum and the Vatican. There is a similar but better known copy of Galen at Vienna (National Bibl., A.F.10), which is closely similar though the handling is perhaps rather more wooden. It must date from between 1220 and 1240, though Stchoukine believes it to be rather later. Holter suggests that it may have been done in Aleppo, but

Jerphanion argues in favour of Mosul because of the similarity of its miniatures to those of the Syriac manuscripts from there; in this case either provenance seems possible.

Of the works of Dioscorides one of the finest copies that have survived is dated to 1224/25 (Top Kapi, 2148, formerly Aya Sofya 3703). As in all the copies of this book, many of the miniatures are simple depictions of trees or plants which were believed to possess medicinal properties, but others are more elaborate and show scenes or groups. The compositions are invariably on a single plane, the figures usually have haloes and the faces are Semitic in contrast to those in the pseudo-Galen or the Kitab al Aghani. The close stylistic relationship to the Syriac Gospel books and the St Vaast Hariri suggests that the volume should be assigned to Mosul.

The style of the miniatures in this book is followed closely by those in a number of other copies, some of them of later date; one is in the Meshed shrine (B.W.G. 162) and others exist in various libraries or have been split up and divided between different collections. Several of them contain notes which suggest that the miniatures were done in northern Mesopotamia. But one example in Istanbul, which is dated to 1229, is in a quite distinct style, for it follows a Byzantine prototype closely (Top Kapi, Ahmet III, 2127; Plate 26). Its frontispiece, with a picture of Dioscorides teaching a pupil, has a gold background like a Byzantine miniature, and though Islamic the faces are Western, while a figure on another page, seated within an arcade, would pass for one of the Evangelists did he not wear a turban. This page is reproduced by Dr Ettinghausen, who suggests that the volume was illustrated at Mosul, but some place in Asia Minor, where the influence of Constantinople was to the fore, would seem more probable. It is hardly to be regarded as a work of the Mesopotamian school narrowly speaking.

So far as it is possible to tell, work in southern Mesopotamia was brought to a halt by the Mongol conquests of 1258. But the style did not die. In the East we see its continuance in the miniatures of al Biruni's *Chronology of Ancient Peoples* at Edinburgh, written probably in western Iran and dated to 1306, and in a few books done perhaps in the north of Mesopotamia. In the West the school left its heritage in Syria and

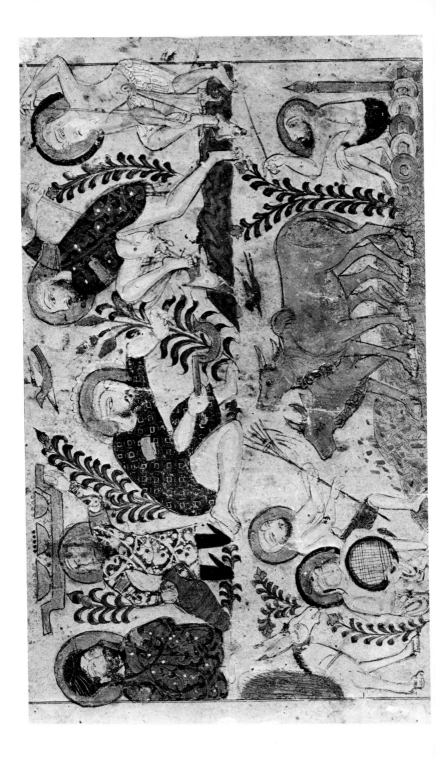

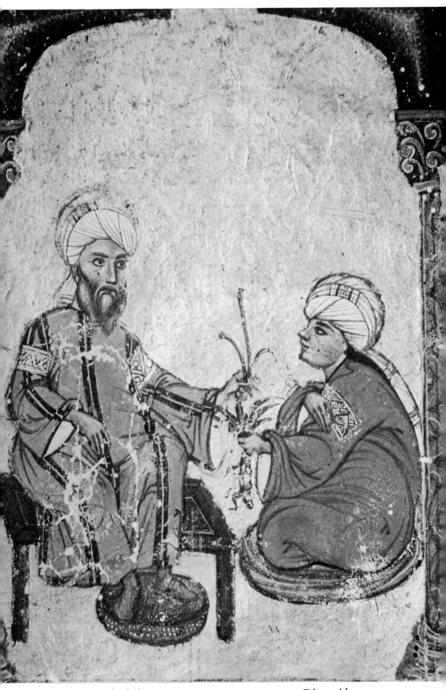

25. MOSUL. *'Pseudo-Galen'*, c. AD 1200 26. ASIA MINOR. *Dioscorides*, AD 1229

Egypt, where the Mongols never penetrated, for their advance was halted by the Mamluk victory at Ain Jalut in 1260. In fact the old manner of the Mesopotamian school underwent considerable development, the outcome of which was the new school which we know as the Mamluk. The style is close to that of Mesopotamia, but is distinguished by brighter colours, by a more abstract approach, where realism is to some extent forsaken, and by a rather stereotyped treatment of the figures. At first glance the very elaborate colours attract – indeed they always remain enchanting – but closer examination shows that the profoundly analytical character and the great powers of interpretation which were such essential features of the Mesopotamian work are not so fully developed; in fact we are in the presence of an essentially decorative rather than an analytical art. In the course of time a hard, almost metallic manner came to characterize this art, which reached its extreme development in the fourteenth century.

One of the earliest examples that may be assigned to this group is a collection of maxims and wise sayings at Istanbul (Top Kapi, Ahmet III, 3206), which is illustrated with a number of scenes which are very like those of the Mesopotamian Hariri manuscripts, though Byzantine elements are rather more to the fore; it was probably done in Syria. But more typical of the style are the miniatures in a manuscript called the *Banquet of the Physicians*, now in the Ambrosian Library at Milan (A.125.Inf); it is dated 1273. The scene where a doctor wakes from sleep to find his servant giving a dinner party in his house is typical (Plate 27a). The schematic frame, the symmetrical balance, the rippling, wrinkled folds of the costumes, and the way that the dishes of fruit or the wine vessels have been reduced to a symbolism almost like that of a painting by Matisse, are all characteristic.

Several copies of Hariri's travels are also to be assigned to the Mamluk school rather than to Mesopotamia, notably one at Vienna, two in the British Museum, and one in the Bodleian. The Vienna copy (A.F.9) is of exceptionally high quality; it is dated to 1334. It opens with a large full-page frontispiece, which as a piece of pure decoration is truly magnificent; the other illustrations are on a smaller scale, but are attractive none the less. Though it is in the main a work of Arab art the

obvious affection for patterned stuffs suggests some relationship with the school of Mosul, while far eastern influence has also penetrated, for though the turban on the head of the central figure is of a type reserved for Mamluk princes, the plumed hats worn by the two musicians are wholly Mongol. Also some of the faces are Turkish or Mongoloid rather than Arab or Persian (Plate 28). They are however rather expressionless.

The illuminations of two later Hariris in the British Museum are rather less decorative, and are closer in style to those of the *Banquet of the Physicians* at Milan. The figures in the first (Add. 22114), which dates from c.1300, are rather large and coarse, and stand silhouetted against a plain background; their rather expressionless character is typical of the less spirited Mamluk work, and the rather flat rendering of the costumes without folds or very much in the way of pattern is also typical, but the compositions are not without charm, notably that of a boat on f. 132r (Plate 27b). The old convention of knotted curtains, however, survives from Byzantine art in some of the illuminations and most of the figures have gold haloes. Long sleeved costumes not known in earlier times also distinguish the miniatures. The second manuscript (Or. 9718), which is dated to 1323, contains numerous miniatures, but all of them are very rubbed; the colours must however originally have been very rich; they contrast markedly with the more subdued tones of some of the earlier books, like the St Vaast Hariri in the Bibliothèque Nationale (Arabe 3929).

There is also a marked interest in decorative motifs comprising numerous scrolls in gold, dark blue and red; most of the figures have gold haloes. The book is to be assigned to Syria; it heralds the bright gaiety of the full Mamluk style, but still shows a good many Mesopotamian features. A copy of Hariri in the Bodleian (Marsh 458) which is dated 1337, is rather more stylized than the others, and some of the illustrations seem almost to have been conceived as pieces of patternwork. But the quality, within this limitation, is high and the book is still a thing of real beauty.

Another important group of illustrations which are sometimes associated with Egypt actually stem from a model dating from around 1181 which was produced in the Ortoquid city of

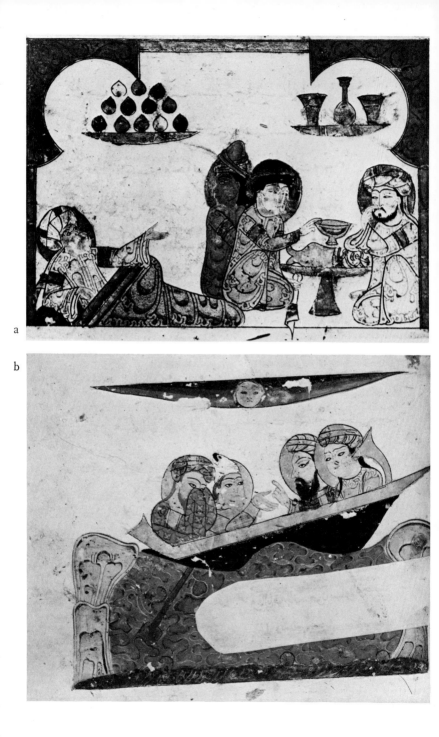

a

b

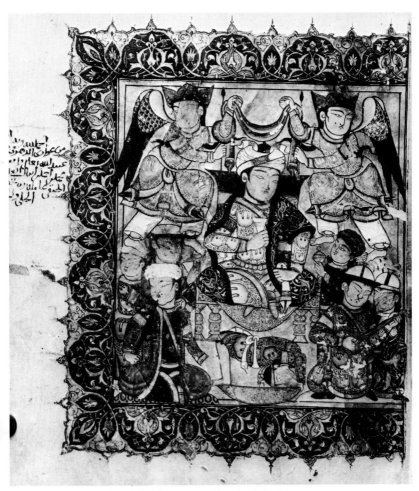

27. MAMLUK School. (a) *'Banquet of the Physicians'*, AD 1273.
(b) *'Travels of Hariri'*, AD 1300

28. MAMLUK School. *'Travels of Hariri'*, AD 1334

Diyarbekr on the confines of Mesopotamia. It is al Jaziri's famous treatise on Automata, which has been discussed above (see p. 51). Several copies were made soon after 1300 in Mamluk Egypt and in Syria and they would seem to reproduce the style of the original fairly exactly. The earliest of these is dated 1315; it has now been broken up and its miniatures are divided between various collections. One of them, depicting an elephant clock, is now in the Metropolitan Museum. A manuscript in the Bibliothèque Egyptienne at Cairo (Rigada no. 487) is probably to be assigned to the same workshop and the same date. Better known is a manuscript in the library of Aya Sofya at Istanbul (no. 3606), though many of its miniatures are now dispersed. It is dated to 1354. Emblems of Egyptian heraldry are included, such as the spread eagle or the chalice in a miniature at Boston representing a clepsydra (Plate 29), but the Mesopotamian heritage is obvious enough as regards the basic subject-matter. The books seem to have been copied frequently and individual leaves or even complete copies are to be found in a number of libraries.

Another book which was just as popular in Mamluk Egypt in the fourteenth century as it was in Mesopotamia in the early thirteenth is the *Kalila wa Dimna* or *Fables of Bidpai*. The stories were often very vividly illustrated, as is indicated by the miniatures of a copy which must be dated around 1360 and is now in the Bibliothèque Nationale (Arabe 3467). The brilliance with which the character and expressions of the various animals is depicted is something quite inimitable; they may perhaps best be described by borrowing the modern term 'empathy'. The painter feels not only sympathy with the animals but something more : he penetrates into and expresses the very essence of their character. The delight of the king of the hares as he entraps his enemy the king of the lions (f. 58v) is particularly captivating, and there is an equally charming scene where the king of the hares takes council with his subjects as to how the hares are to free themselves from their enemies, the elephants (f. 70; Plate 30).

The Paris manuscript has been recently published by Sophie Walzer together with one in the Bodleian library at Oxford (Pococke 400) and two lesser known volumes, one at Munich (Arabe 616) and one at Corpus Christi College,

Cambridge. The Oxford manuscript is dated to 1354, that at Cambridge to 1388, and the author suggests that the Munich one is earlier and the Paris one later than that at Oxford, basing her argument on the greater realism of the illustrations of the Munich book and the greater degree of stylization that is to be found in the Oxford one; the Oxford miniatures show a greater feeling for pure decoration. The Cambridge pictures are a good deal cruder than those of the other three books; in the illustrations of the scene where the hare takes the lion to a pool where it sees its own reflection, the whole sense of the illustration has been lost, for the reflection is shown protruding from the water. In some of the others the point of the story that is illustrated again fails to be appreciated owing to the addition of a number of subsidiary figures which the text does not necessitate. Indeed, artistically speaking, the Cambridge volume is of no great importance, whereas the Oxford and the Paris books, though stylized, stand out because of their decorative charm. This is to be seen especially in the orna-mental way in which the costumes are rendered. The Munich book is however the most forceful and striking and is certainly the closest to the ultimate prototype.

The animal picture books, various versions of which were so popular in Mesopotamia, were also favoured by the Mam-luk painters. A Manafi in the British Museum, with six minia-tures (Or. 2784), has been assigned by Holter to Mesopotamia and dated to around 1250, but its bright colours would tend to support a more Westerly provenance, and an attribution to the Mamluk school seems likely. Holter, however, includes in his Mamluk group a Bidpai in Paris with Persian text (Pers. 2025, Supp. Pers. 1965), which was dated by Blochet to the twelfth century and by others, with greater likelihood, to after 1300.

The extreme of decorative stylization is reached in an animal picture book, the *Kitab al-Hayawan*, in the Ambrosian library at Milan (A.R. AF.D. 140 inf.). Here the plants, birds and animals are completely stylized and the greatest quality of the pictures lies in their delightful, brilliant colouring. The book contains thirty-one miniatures and they bring to a logi-cal but delightful end the work of the Arab school.

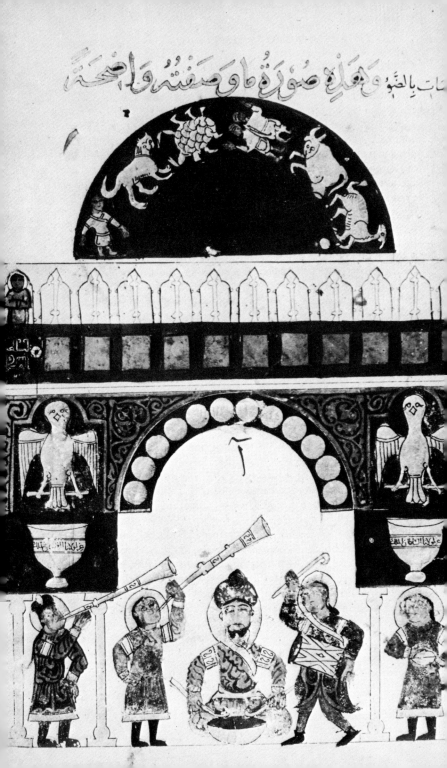

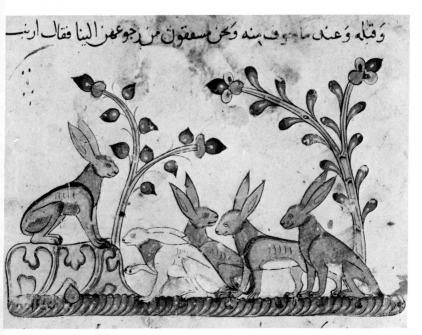

29. MAMLUK School. '*Treatise on Automata*', al Jaziri, AD 1354

30. MAMLUK School. '*Kalila wa Dimna*', c.AD 1360

[1] Feysullah Effendi 1564 (vols. XXI, XXIII and XXIV); 1567 (vol. VII) is late, but undated; 1568 (vol. IX) is dated 1230; 1569 (vol. III) is dated 1252. See D. S. Rice, 'The Aghani Miniatures and religious painting in Islam', *The Burlington Magazine*, XCV, 1953, p. 128.

6

The Mongol School

෴

The Ilkhanid, or Mongol dynasty, was established in control of
the whole Eastern world from China to Syria by 1258 – it
lasted until 1335. But although craftsmen and artists from
Central Asia followed in the wake of the Mongol conquerors
and settled in north-western Persia in such cities as Maragha,
Tabriz and Sultaniye, the effect on art was at first hardly ap-
parent. In Iraq, work in the old manner continued for a time
with little interruption; in Persia the destructions wrought by
the Mongols account for the fact that there are very few works
which can be assigned to the years between about 1250 and
1290. Thereafter, however, there was a tremendous burst of
energy, and during the first half of the fourteenth century
some of the most superb examples of Islamic painting in the
history of the art were produced there. Their style is in the
main quite distinct from that of Mesopotamia, as a comparison
of the illustrations of the famous manuscript of Rashid al Din's
Universal History, done at Tabriz in 1306, with a typical
work of the Baghdad or Mesopotamian school like the Schefer
Hariri in the Bibliothèque Nationale, serves to show. But the
new style was at first a very mixed one; there were numerous
variations, and it would seem that the essentially Mongol
manner was only evolved somewhat slowly. A manuscript of
outstanding interest which is preserved at Edinburgh, al
Biruni's *Chronology of Ancient People*, was written in 1307,
and is in a style closely linked to that of northern Mesopo-
tamia, while the famous Morgan Bestiary (no. 500), done
eight or nine years earlier, contains some miniatures which are
basically Mesopotamian in style while others show a marked
Far Eastern influence.

This manuscript was executed at Maragha in 1291[1]; its cor-

rect name is the *Manafi al Hayawan of Ibn Baktishu* and the text is in Persian. A few of its miniatures may be mentioned, for they illustrate the two styles. Some of them, like that showing Adam and Eve, or that of two bears (Plate 31b), are solid and formal and follow the Mesopotamian tradition; others are fanciful and imaginative and are essentially Chinese, like that depicting two magpies chattering in trees (f. 60v), or that of a Phoenix (Plate 31a). In the miniatures of the former group, the figures are on one plane, and the foliage follows the old conventions which were characteristic of the Galen, Dioscorides or Hariri manuscripts done in Mesopotamia. In those of the second group, the foliage is more naturalistic, the ground is shown in several receding planes and the whole approach is illusionistic. The landscape in fact constitutes a true background to the figure subjects. Chinese motifs, like the cloud form or the phoenix, appear frequently, and the trees in the miniatures of this group have the pendant branches which were later to characterize willow-pattern plates and other essentially Chinese works of art. Most of the paintings are enclosed in frame-like margins, but at times parts of the picture stray outside them in a way which was to become very usual at a later date. A leaf on which a massive elephant is depicted is especially interesting, for it shows a subtle blend of the two styles and the same is true of an intrusive scene which depicts the murder of Abel by Cain; this leaf takes us even further afield, for to the solid forms of the Mesopotamian heritage and the fantasy of the Chinese there is added a hint of Buddhist art of Central Asia. The mixed art that we see here was to continue for many years, for the same divergent styles are to the fore in another Bestiary, done some sixty years later, and now preserved in the Escorial (Cod. Arabe 893); it is signed and dated 1354 but its provenance is uncertain; Ettinghausen attributes it to the Mamluk school, but western Persia is perhaps more likely. There is also a fragmentary Bestiary of similar character in the Freer gallery at Washington.

There is little of this fantasy to be found in the al Biruni at Edinburgh University (no. 161) even though certain Far Eastern elements like the 'kilin', the conventional Chinese cloud form, or knobbly trees with pendant foliage of a

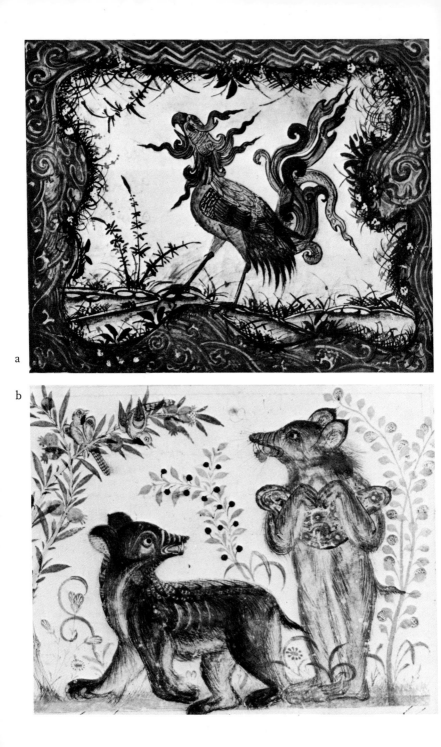

a

b

31 (a) & (b). MARAGHA. '*Manafi al Hayawan*' (*Morgan Bestiary*), AD 1291

32. NW PERSIA. Al Biruni, '*Chronology of Ancient Peoples*', AD 1307

wholly Far Eastern character, appear in some of the minia-
tures. The figures, on the other hand, nearly all have haloes of
Christian type; the folds of the costumes imitate Byzantine
models, improperly understood, and the general style is closely
related to that of the Hariri manuscripts. It is unfortunately
uncertain where the work was done, but somewhere in north-
western Persia seems most likely. The poses of many of the
figures, the shading and high-lighting of the costumes, the
solid rendering of the buildings, the single plane used in most
cases in the rendering of the ground and the brilliant primary
colours all belong to Iraq. The death of the Prophet Eli (f.
133v) may serve as an example (Plate 32a).

The manuscript is especially interesting because it contains
in addition to several scenes from the Old Testament, such as
the Death of Eli and the Temptation of the First Man and
Woman, a number of others from the New, notably the
Annunciation and the Baptism. Several of the scenes, like that
of the Temptation of the First Man and Woman (f. 48v) are
set in landscapes where the multiple planes of the backgrounds,
the knobbly tree-trunks and the pendant foliage are ultimately
Chinese (Colour Plate 11); the treatment of the costumes and
the haloes, on the other hand, derives from Byzantine models,
though the iconography of the Bible scenes is quite distinct
from that known in the Byzantine area. That it is the tempta-
tion of Adam and Eve with the aid of the apple of knowledge
that is represented is obvious enough – but the depiction of
the tempter as a venerable old man with a halo is different. Sir
Thomas Arnold has explained this by citing the Zoroastrian
legend of the temptation of the first man and woman by
Ahriman the Spirit of Evil, who appeared to them in the guise
of an old man and persuaded them to eat of the forbidden
fruit; on doing so himself he was transformed into a hand-
some youth. It is probably a Manichaean version of the story
that is depicted here; the story of Adam and Eve, the person
of Jesus and other Christian figures and much of the Christian
teaching was known to members of this faith, but in their
rendering of the various themes a distinct system of icono-
graphy was invented by them.

In the representation of the Baptism (f. 140v) similar varia-
tions on the normal Christian rendering of the scene are to be

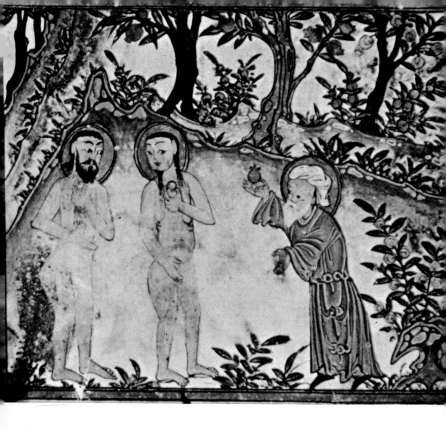

observed. The faces are Central Asian, the Baptist's shoes are of a type usual in Turkestan, and the necessity of clothing Our Lord in a shirt belongs to an Eastern rather than a Christian thought-world. In fact, we seem once again to be in the presence of a Manichaean interpretation of a Christian theme, and the same is true of the rendering of the Annunciation (f. 141v). Another unusual scene which also shows the influence of Manichaean ideas is that on f. 10v, where two figures are depicted riding, one on a camel, the other on an ass (Plate 32b). The picture illustrates a text of Isaiah, 'and behold I see a man riding on an ass and a man riding on a camel; and one of them came forward crying and said, Babylon is fallen, and all the graven images of her gods he hath broken on the ground'. The man on the camel is to be identified with the Prophet Muhammad whose conquests in Mesopotamia had accomplished the fall of Babylon : the man on the ass is Jesus. But some of the other miniatures like that illustrating the Night of Alsadhak (f. 103v), when fires were lit on the roofs of all who had been saved from death by Asmail, are distinct and seem to herald many of the elements that were to become typical of Persian art a century later. The architecture, the placing of the figures, and the gesture of surprise are thus all very Persian in spirit, and are paralleled in many a rendering of the favourite garden scenes of the fifteenth century; but the colouring and style, on the other hand, still retain many of the features characteristic of the Mesopotamian school. There is a close copy of this book in the Bibliothèque Nationale (Arabe 1489) which dates from the seventeenth century.

The mention of Manichaean art gives rise to the question of Central Asian influence, and more particularly to the role played by Uighur artists. Before we go further it would perhaps be well to try to give a definition of what this Uighur element was and what it stood for. The Uighurs were a people of Turkish race who served the warlike Mongols as scribes and illuminators. Schooled in Central Asia, in the service of Buddhists, Manichaeans and Nestorian Christians alike, they brought to the art of Iran a style which had been first developed in fresco painting and which had therefore a certain degree of majesty about it, though it was basically a linear style rather

11. Temptation of al Biruni, '*Chronology of Ancient Peoples*', AD 1307. See p. 83

than a monumental one. It is represented by the illustrations to a fine *Shah Nama* at Istanbul dated 1330; a scene of the death of two heroes or one with two figures may be noted (Plate 12).[2] There is something of the Chinese in the mountains, but the bright colours are quite distinct from anything Chinese or Mongol; they recall those of the al Biruni on the one hand and are suggestive of the cave paintings of Central Asia on the other. It has even been held that the first of these miniatures actually reproduces a painting that had originally been executed on a wall on a monumental scale.

Another feature which is also probably to be regarded as characteristic of Uighur art – if Holter's classification is to be accepted – is the presence in landscapes of little tummocks of grass, regularly arranged over the ground. Holter notes that such landscapes are closely akin to those in paintings in caves 19, 20 and 21 at Chotso.

The role played by these Uighur painters deserves closer attention than it has received in the past, but care should be taken to distinguish the style as a limited entity, and not to assign everything that came from the east to the Uighurs. We must not give them the credit for the development of the essentially Arab art of the Mesopotamian school in the thirteenth century or attribute to them all the work produced in Persia before about 1350, as certain Turkish authorities wish to do.

Elements that are no doubt Uighur are found along with numerous others in a series of manuscripts of a book called the Universal History which was produced at Tabriz in the first decade of the fourteenth century under the patronage of the Grand Vizir of the day, Rashid al Din. In these manuscripts the early fusion of the various elements that were soon to coalesce to form a truly Persian school can be most satisfactorily examined. The finest manuscripts now belong to Edinburgh University (Or. 20) and to the Royal Asiatic Society in London: the latter is now kept in the British Museum; it is dated 1314, while the former was done eight years earlier, namely in 1306. Although at one time they were apparently bound up together, they actually belong to separate, but closely related, editions of the book. Both of them contain miniatures by several different hands and in somewhat diverse

33 & 34. TABRIZ. Rashid al Din, '*Universal History*', AD 1306

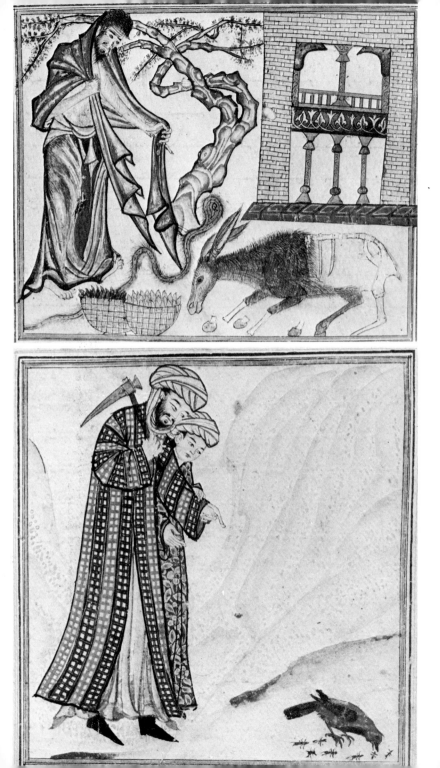

styles, though they all have certain features in common, notably the thin, tint-like colours, the dominantly fine outlines, and often the use of silver for flesh tints or even for parts of the costumes. The most characteristic and the most striking of the miniatures are those that attest the influence of the Far East. A miniature may be chosen from each of the two volumes to represent this Chinese style, a landscape with trees, houses and figures in a wholly Chinese style from the London book (f. 22; Colour Plate III) and an enchanting page from the Edinburgh copy showing the Prophet Jeremiah (f. 13v; Plate 33). The prophet had expressed doubt as to God's power to raise Jerusalem again after its destruction; he is consequently made to die for one hundred years and is then brought back to life and his donkey's skeleton is reclothed with flesh and skin before his eyes. It is a vivid and enchanting rendering. In both these miniatures the gnarled, knotted tree trunks, the feathery branches, the strange, fantastic mountains and even the figures themselves must all have clearly been inspired by the art of the Sung dynasty of China, and the same is true of many other miniatures in the two volumes, for example the mountains at the back of the scene representing the discovery of the well of Zamzan, where a crow pecks the ground (Plate 34).

But these are not the only Eastern elements in the illustrations of the Edinburgh and London Rashid al Din manuscripts. A large number of the miniatures, though wholly oriental, are to be described as Mongol rather than Chinese. Their Mongol character is especially obvious with regard to the costumes and accoutrements worn or carried by many of the figures, such as the head-dresses with their flap-brims and little top-knots, the spears with horse-tail pennants, or the link mail, while the faces, with their slit eyes, are also Mongol rather than Chinese. These features appear most frequently in a number of battle scenes in the latter part of the book, all of which are by someone who worked in a style quite different from that of the painter who was responsible for the miniatures of more Chinese character in the earlier part of the volume. The scene showing the Ghaznavid Emperor Mahmud ibn Sabuktagin crushing the forces of Ibn Sayimjur at Tus is typical of his work (Plate 35a). Also Mongol are some of the

III. Landscape in Chinese style. Rashid al Din
'Universal History', AD 1314. See p. 88

textiles, with their severe geometric patterns like those worn by some of the spectators in the scene of the Prophet's birth (Plate 35b); how different are these from the elegant figured silks of Sasanian or Byzantine art, or even from the striped stuffs that appear in the Samarra paintings. It is miniatures in this style that predominate in the Edinburgh volume – and they may be taken as virtually type examples of the early Mongol school.

In some of the scenes these angular elements in the Central Asian textiles are mingled with elements which must surely have been derived from the Byzantine world. Thus the convention of the knotted curtains that appear in the same scene must clearly have been inspired by a Byzantine prototype – the mosaics of St Appolinare Nuovo at Ravenna may be cited – while the arrangement of the scene itself is also clearly derived from a Christian rendering of the Nativity of Our Lord or the Virgin. On other pages of the Edinburgh manuscript there are vestiges of the old Mesopotamian manner, as in the scene of the Finding of Moses by Pharaoh's daughter (f. 7). Here the water is shown as a firm, solid convention, very far from the imaginative idealism of the Chinese landscape style. The same is true of the very expressive and effective scene from the life of Jonah on f. 23v, where Jonah is resting under his gourd tree after being spewed up by the whale (Plate 36).

These pages serve to illustrate the diversity of hands working on the Edinburgh copy of Rashid al Din's *History*. It must be admitted that some of the miniatures are to be regarded as no more than competent illustrations to the text, but others far excel this, and the rendering of Jonah is really very outstanding as a picture; its high quality is made particularly apparent if it is compared with the rendering of the same theme in the London volume, where all the movement and spirit of the Edinburgh version are lacking. A number of the other pictures are little less effective; that showing Mohammad and Abu Bekir resting beside a herd of goats on f. 57r, for example, is imaginative, fanciful and wholly delightful. The two travellers ask for milk but are told that the goats are too emaciated to give any; the Prophet strokes the back and the udder of one of them, and it gives enough milk for all. The 'kilin', the conventional cloud

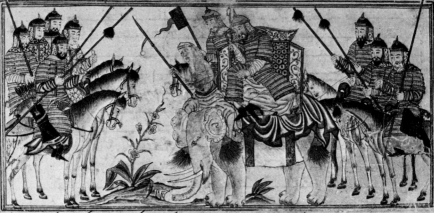

35. **TABRIZ.** Rashid al Din, '*Universal History*', AD 1306

36 (opposite). **TABRIZ.** Rashid al Din, '*Universal History*', AD 1306

form of China, is subtly blended with the more wholly Mongol manner in another most important picture which represents Alexander penetrating into the lands of northern fog; one would almost think that the painter had lived through a London winter.

Though it is thus possible to distinguish not only a number of hands but also a number of stylistic influences in these illustrations, there is nevertheless something more than their presence all together in the same book that binds them one to another. That character is to be attributed to the fact that they were all produced at the command of the same patron in the same place, namely Tabriz. The city had risen to importance soon after the Mongol conquest and was by 1300 the most flourishing centre in western Asia. It was there that Rashid al Din lived till his death in 1318, and there that he collected round him a group of learned and cultured men, with whose assistance he undertook the compilation of his *Universal History*. And he collected at a centre known as the Rashidiyya a number of scribes and illuminators, one of whose tasks was to produce each year two copies of the History, one with a text in Arabic and one with a text in Persian. His scribes were apparently well occupied, for the texts record that a number

of books were produced. Alas, only very few works of the school have survived; they include the illustrations to two fragmentary copies of the History in the Top Kapi Saray at Istanbul (nos. 1653 and 1654), a volume of poems, the Diwan of Muizi, in the India Office Library, dated 1315,[3] and a number of miniatures pasted into albums in the Saray. These miniatures are all a good deal clumsier than those in the Edinburgh and London copies of the *History*.

A copy of the *History* in the Bibliothèque Nationale (Supp. Pers. 1113) and some leaves scattered in other collections, though at one time assigned to soon after 1300, are actually to be dated about a century later. Their style follows that of the example in the Bibliothèque Nationale. This was indeed probably copied for Shah Rukh, who made a collection of copies of Rashid al Din's great work (see p. 109). The Paris manuscript contains some very impressive illustrations, some covering a double-page spread (Plate 37); they are to be described as pictures rather than miniatures and stylistically speaking they seem to herald the style of the next manuscript we must mention, even if they are of later date.

If the illustrations to Rashid al Din's *History* afford a basis on which to begin a study of stylistic elements prevalent in the early fourteenth century, an investigation of the developments that had been made by about 1350 may be centred around the illustrations of another book, one of the finest ever produced in Persia. It is usually known as the 'Demotte *Shah Nama*', but should perhaps more justly be designated as the 'Great *Shah Nama* of Tabriz', for it was there that it was written, and there probably that most of its illustrations were done. Its miniatures – fifty-five of them are known – are by a number of different hands and show considerable variety; they are now split up among numerous collections in Europe and the USA. The Far Eastern elements are very much less to the fore than in the Edinburgh and London volumes of the Rashid al Din, but the book is of the same large size, a tall folio, and considerably greater portions of the page are given over to the illustrations so that they are on a monumental scale; most of them are also monumental in character.

The style of the painters responsible for the illuminations of the Demotte volume varies considerably. One of them, for

IV. Bahrain Gur kills a dragon, Demotte '*Shah Nama*', AD 1330. See p. 94

example, was working in a manner close to that of the Rashid al Din. This is clearly to be seen if the rendering of the scene where Rustem kills Shahgad is compared; it is, happily, depicted in both volumes (Plate 38).[4] The version in the Edinburgh Rashid al Din is treated in a more linear manner, and colour plays a less important role, for it is really only a tinted drawing whereas the other is already a painting. But more important is the difference in interpretation; the Edinburgh version is more dramatic, more violent, while that in the Demotte is distinguished by the poetic, lyrical approach that was soon to become characteristic of Persian painting as a whole.

The painter of this scene may be termed the conservative master and one or two other pages, like that where Alexander visits the city of the Brahmins, are also to be attributed to him. In the work of the other men who were engaged on this volume, elements that were later to become characteristically Iranian are a good deal more marked. Rich, heavy colours are used in place of the gentle tints of the earlier works, brilliant blue or gold skies take the place of the almost colourless ones, and, most important of all, the stories are told with a new enthusiasm, and a new feeling for progressive narrative, so that the compositions of the paintings are truly interpretive of the events in the scenes depicted. This is especially the case in scenes where battles or struggles with monsters are involved; Alexander's 'Iron Horses', breathing out flames from their nostrils, are terrifying even in these days of tanks and flame-throwers. A number of scenes are devoted to the story of Bahrain Gur; he goes hunting (Colour Plate IV) and kills a dragon for example. Here the swirling movements of the beast are not only impressive but also brilliantly expressive of the courage of the hero and the thrill of the adventure. Or, in the scene where Ardawan is brought as a captive before Ardashir, the varied emotions of the protagonists are rendered with astonishing feeling; the conqueror is possessed of a wholly oriental grandeur, while the prisoner is depicted with a profound understanding of the misery of his plight. The man who painted this scene has aptly been termed the master of the pathetic, and we see his work again in the very expressive funeral of Alexander (B.G. 32).

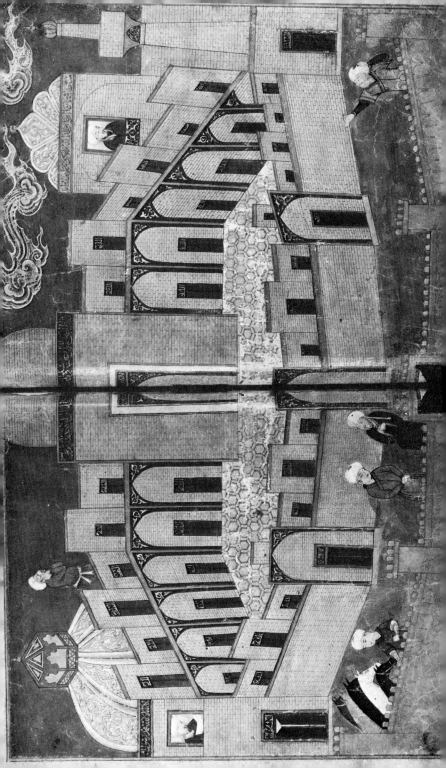

The last scenes to be done, perhaps a considerable time after the early ones, were probably those where grand events were depicted or those scenes illustrating some of the more intimate tales of the Shah Nama. One of the most striking of the former, now in the Chester Beatty Collection (no. 111), shows a king on his throne with three personages before him (Plate 39). The figures are depicted in a solid, colourful manner that is on the one hand reminiscent of Sasanian art, though on the other it heralds the numerous court scenes of the Timurid period; Grube has recently associated it with Samarkhand.[5] The shading of the costumes perhaps owes something to Byzantine art, but there is nothing eclectic here; the elements have completely coalesced to produce a wholly new style, and this is even more apparent in the scene where Zal climbs a rope-ladder to reach his adored Roudabe, princess of Kabul. Here there is a new preoccupation with the story for its own sake, and the narrative aspect is almost as developed as in work done around 1400.

There has been a good deal of dispute among the authorities with regard to the date of this manuscript. Binyon, Wilkinson and Gray think that it must have taken at most six years to finish, and date it to between 1330 and 1336; Stchoukine thinks that work must have gone on over a period of fifteen years, from about 1330 to about 1345, while Schroeder dates it to between 1350 and 1370. A date between 1330 and about 1335 seems on the whole most likely and the differences of style are to be attributed not so much to later and earlier dates as to the more progressive and more conservative manners of the individual painters.

If this date in the thirties is accepted, it is tempting to assign to about 1360 some miniatures from the *Fables of Bidpai* from the Yildiz Palace and now in Istanbul University (F. 1422, B.G. 35, 38, 39). Their delicate style, already truly Persian, supports such a date and there now seems every reason to discard Sakisian's attribution of the manuscript to the twelfth century as well as Schroeder's to a date just before that of the Demotte *Shah Nama*. The same applies to some pages from a *Shah Nama* bound up in albums in the Saray; the most important is numbered Hazine 2153 (B.G. 5 41, 42, 43). It is however not so certain where they were done, for

37. TABRIZ. Rashid al Din, '*Universal History*', c.AD 1410

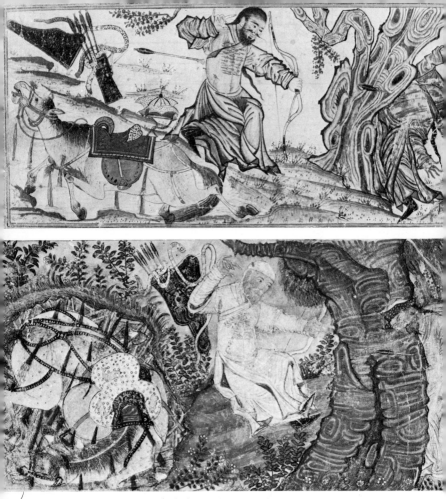

38. TABRIZ. (a) Rashid al Din, '*Universal History*' c.AD 1306 (EUL). (b) Demotte '*Shah Nama*', c.AD 1330

39. TABRIZ. Demotte '*Shah Nama*' (Chester Beatty Coll.),
*c.*AD 1330

by this time Tabriz was no longer the primary centre, and it has been suggested that the miniatures should be assigned to Baghdad where a new school of painting had been established under the patronage of the enlightened sultans of the Jala'irid dynasty (1336–1411). And if this was so, some leaves of a *Shah Nama* bound up in several more of the Saray albums (Hazine 2150, 2152, 2154 and 2160) were no doubt executed at the same centre; the style of the work is however rather closer to that of the Demotte *Shah Nama* than it is to that of a volume which was undoubtedly done at Baghdad, the *Book of Marvels of the World*, now in the Bibliothèque Nationale (Supp. Perse 332); it is exactly dated to 1388. Its miniatures are less monumental and much simpler in conception than those from the Istanbul Bidpai and Shah Nama. On the other hand the *Diwan* of Khwaja Kirmani, now in the British Museum (Add 18, 113), which was also undoubtedly done at Baghdad eight years later, is one of the grandest volumes of the whole of Persian painting, already showing the brilliant accomplishment of the fully developed Persian art of the fifteenth century (Plate 40). It was the work of a master called Junayd, the first of a long line of painters whom we know by name. It contains nine miniatures of the very highest quality, most of which occupy a whole page, without any script above or below; one of them which is less well known than some of the others, is reproduced here (f. 45v; Plate 41); it illustrates a scene of dancers in a palace.

In addition to the schools of Tabriz and Baghdad, where work of the greatest grandeur and magnificence was produced, several other centres existed, though the books produced in them were on a smaller scale and the paintings that decorated them were rather less distinguished. In place of the elaborate backgrounds, the brilliant colours and the rather crowded compositions we see great reticence; only the minimum of detail is included, while the number of figures is vigorously limited; and in contrast to the great dexterity and technical accomplishment of the Tabriz and Baghdad work, the miniatures done in other centres seem crude and clumsy. Yet these are not without charm and are especially interesting in that they represent what was probably the native art of Iran, undiluted by Chinese, Mongol, Uighur or Arab

influences. These paintings have been compared to those that appear on the pottery of the period, especially that known as 'minai' ware, and both represent an old trend and tradition.

There appears to have been an active centre of production in Khorasan, and several of the most typical books of the age have been assigned to that area, notably some of the so-called 'Red Ground' *Shah Namas*. These are all comparatively small in size – one might call them large octavos – and the illustrations occupy narrow horizontal strips with extensive areas of text above and below (Plate 42a). The figures are vigorous, but the drawing is rather careless and the colours are restricted, though the general effect is quite striking because the backgrounds are usually very brilliant, gold, yellow, or more often red, being used. The colours in general, and especially the red backgrounds, recall those of the cave paintings of Central Asia, a fact which supports the association of the school with eastern Persia.

There was another distinct and quite active school working at Shiraz under the patronage of the Inju dynasty (1335–53); its products were crude and essentially provincial. The most important example is a book in three volumes called the *Kitab i Samak Ayyar* now in the Bodleian library at Oxford (Ousley 379–381). The illustrations in the third volume would seem to be by a different hand from those in the other two. One of the miniatures in the first volume depicting a presentation to a queen (f. 209; Plate 42b) may serve both to illustrate this rather crude style and to indicate the debt to the more polished work of an earlier age. The figures thus recall those of work of the Mesopotamian school, while the jagged mountains in the background represent an ungainly survival of those in a Far Eastern style which appear in the Edinburgh al Biruni. A *Shah Nama* at Istanbul done in 1339 is also probably to be assigned to this group. The Inju school developed very rapidly, but vanished equally quickly when Shiraz fell to the Muzaffarids in 1353, and we know little of what was done thereafter till Shiraz became a leading centre under the patronage of the Timurids at the end of the century. It is however possible that some of the 'Red Ground' *Shah Namas* were done under Muzaffarid patronage.

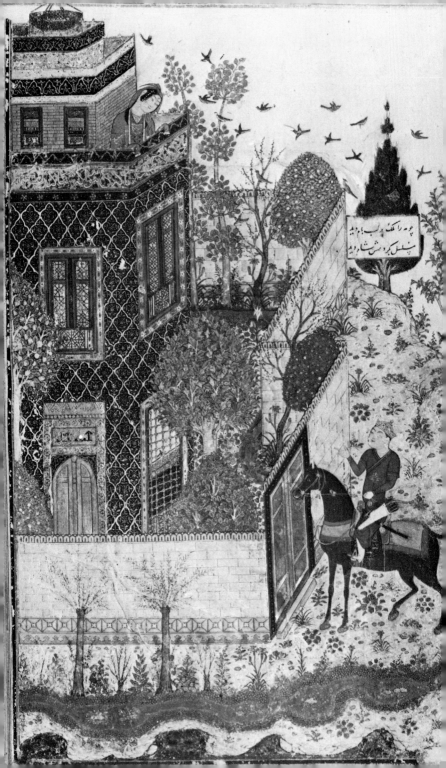

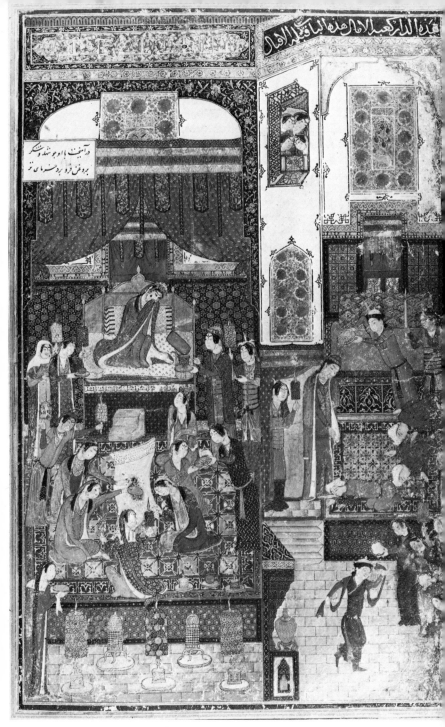

40 & 41. BAGHDAD. Junayd, *'Diwan of Khwaja Kirmani'*, AD 1396

There seem to have been schools of painting at several centres other than Shiraz, and Robinson has listed a number of manuscripts illuminated between about 1380 and 1410 which are broadly in the Shiraz style, but which can be associated with Baghdad, Tabriz and Herat as well as with Shiraz istelf.[6] But problems of classification, more especially those of association with definite localities, are very complicated and need hardly concern one in a general survey of the type that is attempted here.

By the end of the fourteenth century these local schools had become very much of a side issue, and it was already apparent that a new age was dawning, which was to come to fruition under the lavish patronage of the Timurids in the next century. One or two very outstanding manuscripts herald it, one of the most delightful of which is an Anthology of the works of seven poets, now preserved in the Türk ve Islam Müzesi at Istanbul (no. 1561, B.G. 69; Plate 43). It serves to bring us back to the main stream of development, where artistic quality was the governing factor, for its miniatures are amongst the most delightful and accomplished that we know. It dates from 1398, and most authorities are agreed that it was executed in Shiraz, though Stchoukine assigns it to Turkey, thinking that the bulbous hills and the pale, tender colours are more Turkish than Persian.[7] If the date of 1398 is correct, an attribution to Turkey seems hardly possible. If the miniatures are Persian it seems likely that other works of the same excellence may have been done under the patronage of the Muzaffarids (1353–93), for it is hard to believe that the Istanbul manuscript could have stood alone or have been executed without at least a few predecessors of high quality. The miniatures are unusual in that eleven out of the total of twelve are all landscapes. All of them are redolent of the intense love of nature that plays so important a part in later Persian painting and seems to reflect the Mazdaean concept of the Hvarenah, the divine radiance of the created world. But in few other instances are landscapes treated in so imaginative and conceptual a manner. Mountains are treated as great masses of what can only be described by borrowing the term 'significant form' from the vocabulary of modern art criticism. Rivers coil and twist like serpents; cypresses and other trees

tell by the loveliness of their contrasting shapes, but they are coloured gold, red or white; birds perch in impossible attitudes on the flimsiest of twigs, their tails extending over the neatly ruled margins, while further trees and lovely decorative patterns are silhouetted above, against a brilliant lapis-blue sky, into which the text obtrudes, a thing of exquisite beauty in itself. No story is illustrated here, no tale is told, yet these miniatures constitute one of the most complete and perfect expressions of the Persian spirit in art ever to have been produced.

[1] Holter, no. 57. Stchoukine no. 11. This would appear to be the correct date and not 1294; see Armenag Bey Sakisian, 'L'exposition de manuscrits et d'enlumineures Musulmans du Metropolitan Museum of Art de New York', *Syria*, 1934, p. 277.

[2] It is reproduced in colour in the Unesco volume on Turkish painting by Ettinghausen, Ipširoglu and Eyuboglu.

[3] Holter nos. 68 and 69. The manuscript consists of several parts, nos. 903, 911, 913, 1028, 1029 and 1030, now bound up together as I.O. 132.

[4] The comparison was first made by M. E. de Lorey 'L'Ecole de Tabriz' in *Revue des Arts Asiatiques*, IX, 1935. See also Basil Gray, *Proceedings of the Iran Society*, Vol. I, pt. 3, 1937, p. 56. He stresses the artistic excellence of the Demotte version.

[5] *The Classical Style in Islamic Painting*, 1968, Plates 2–12.

[6] B. W. Robinson, *A Descriptive Catalogue of the Persian Paintings in the Bodleian Library*, Oxford, 1958, p. 10.

[7] *La Peinture Turque*, Paris, 1966, p. 111.

42 (a) KHORASAN. 'Red Ground *Shah Nama*', 14th cent.
(b) SHIRAZ. '*Kitab i Samak Ayyar*', c.AD 1350

43. Probably SHIRAZ. *Anthology of poetry*, AD 1398

7

The Fifteenth Century

ਤ

It is a curious fact that the sponsorship of Persian painting, the most gentle and wholly delightful of all the world's great arts, was on two occasions associated with the most ruthless and bloodthirsty conquests. The first developments of a truly Persian style in painting, as we have seen, were ushered in as a result of the Mongol conquests in the latter part of the thirteenth century, while the full maturity of the art was associated with another phase of hostile activity under the formidable Timur, or Tamerlane as he is more generally known in the West. His sons and grandsons were among the greatest and most ardent patrons of miniature painting that the world has known, and it is the work that was done for them that shows us Persian miniature painting at its height. It is true that no new elements were introduced into painting at the time of this second age of supremacy as they had been at the first, for the art was already formed; instead it underwent a steady and progressive development, without any marked stylistic break between the latter part of the fourteenth and the late fifteenth century. Art as a whole was distinguished by a remarkably high standard of universal excellence at this time, and painting was given new encouragement and a new energy thanks to the very lavish and discerning patronage accorded to it by a long succession of rulers and local governors.

A comparison with the other arts, and more especially the pottery, shows that there were numerous centres where good work was being produced, but in the case of painting, the exacting and selfish patronage of Tamerlane saw to it that all the best artists were, during his lifetime, drawn to his beloved Samarkhand, and from about 1369, when the city became his capital, till the early years of the fifteenth century – he died

there in 1405 – it was the main centre of activity. There are records of wall paintings that adorned garden pavilions attached to Timur's palace, but nothing survives, nor is it possible to associate with Samarkhand any actual illuminated manuscripts other than one containing Tables of the Fixed Stars in the Bibliothèque Nationale (Arabe 5036) which was done for Ulu Beg about 1409. Kuehnel suggests that a few leaves in a rather Chinese style which have survived, though they are now dispersed, may also have been executed there, but if we may judge by the work done in other cities in the early fifteenth century this Far Eastern influence was superficial, and well before the turn of the century the majority of the paintings were already in a truly Persian style and even the basically Central Asian elements like the flame haloes, to be seen behind the head of the Prophet in such scenes as that of his ascension, had been completely transformed and Persianized.

At Timur's death his son Shah Rukh succeeded in substantiating his claims as ruler of Transoxiana and Persia, but he moved his capital to Herat, and there it remained till his death in 1447. He was an able and just ruler and ranked as a patron of the greatest discernment, both in the spheres of art and more especially of literature of a serious character. It is thus not surprising that one of the first enterprises he chose to sponsor was a re-issue of Rashid al Din's great *History*; the volume of the original issue dated to 1314 and now owned by the Royal Asiatic Society was at one time in his library, and there is a copy of the revised version in the Bibliothèque Nationale (Supp. Pers. 1113; see p. 94) which was probably done for him. It was perhaps also in studios working for him that some illustrations were added to an incomplete copy of earlier date now preserved at Istanbul. Neither these miniatures nor those of the Paris copy show any very close resemblance to the original illustrations. More important are those in another volume produced under Shah Ruk's sponsorship, a *Miraj Nama* or *Life of Muhammad*, now in the Bibliothèque Nationale (Supp. Turc. 190), which was copied in 1436. Its text is in Jagatai, a Turkish dialect which was in common use in Transoxiana at the time, and this has led to its being claimed as the product of Uighur artists. This is unlikely, for its

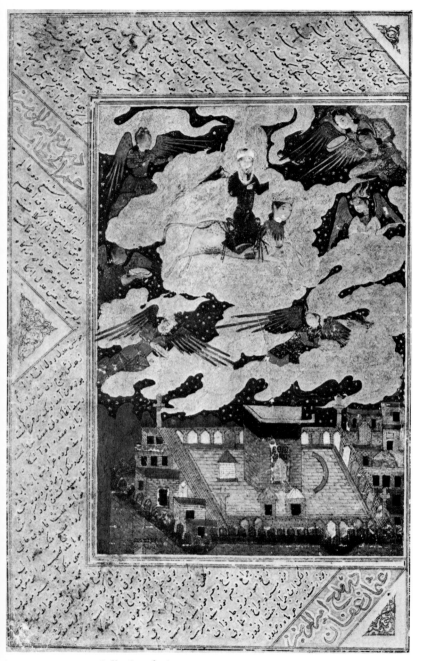

44. SHIRAZ. *Collection of epics*, AD 1397

45. SHIRAZ. *'Khamsa of Nizami'*, AD 1410

miniatures are essentially Persian and are closely related to other work done by truly Persian artists at the time. They are characterized by great ardour and emotion, though they are somewhat dry and limited in comparison to the best work of the mid-fifteenth century.

Shah Rukh established a very active school of manuscript production at Herat, but throughout most of the first quarter of the fifteenth century it must be admitted that Shiraz was probably more important, thanks to the patronage of a series of governors of Fars, both in Timur's time and subsequently. One of the earliest manuscripts of this phase is the anthology of the poets at Istanbul mentioned above (see p. 104) – it is dated to 1398 and contains a number of enchanting landscapes – while a pair of volumes of epics, one in the Chester Beatty collection and the other in the British Museum (Or. 2780) date from the previous year. But even though they are early in date they exhibit to a more marked degree certain features which were soon to become characteristic of Shiraz work, notably a very high horizon and the inclusion of a hill from behind which figures loom up; this was used as a device for indicating depth. These features are to be seen to an exaggerated degree in a miniature on f. 44v of the British Museum volume (Plate 44).

Another pair of anthologies done in 1410 for Iskander Sultan, who ruled at Shiraz from 1409 to 1414, are preserved in the Gulbenkian collection (B.G. 74–79) and in the British Museum (Add 27,261); both contain miniatures by several hands and show the full maturity of the Shiraz school. The faces are finely drawn, with narrow eyes and sideways glances, and there is to be found here a new and wholly delightful interplay of miniature, script and margin, for the margins are usually elaborately decorated either with birds, animals and foliage or with script (Plates 45 and 46). These Shiraz manuscripts, together with later ones done at Herat, perhaps show little that is new in comparison with those of earlier phases, but their miniatures do indicate a gradual progress towards perfection of technique and mastery of detail, and present us with a picture of the soundness of the foundations on which the great art of the last quarter of the century was built. Then a number of individual masters of outstanding excellence were

46. SHIRAZ. '*Khamsa of Niẓami*', AD 1410

او بکار آب آمد واندکی بخورد و سرسانی پشت با زاغ چون دید زاغ چون می خورد و می شاید برفت و بکر پیت که در آب او کسی پشت

چون بر جای بنشست و کرم می دوزو سنگ پشت را آواز داد و او خوش بنشر حاضر آمد و چون سنگ پشت دید که او آب نمی خورد

گفت آب کرفته بخورد وبا کره آب مبارک که خوش نیت آمد مشرف و سنگ پشت اورا مرحبی تمام واجب داشت و بر پیکه حال

چیست گفت من درین مدت جدا بودم و تیرانداران مرا از جای بجای می کشیدند تا خدا امروز پر مردی دیدم بحال کنان بدم که وصیات

این جانور بخم سنگ پشت کم سم پس که درین حوالی سرکرد صیاد دیده ام و دوستی خویش تام بندول داریم و چه خورده بازده

و بهجت ایشان بنود و در ان غذار بود و زنی بست که ایشان در ان جمله بش نمی و بار بزی کردنی و سکر که کشتی کشتی

روزی زاغ و موش و سنگ پشت وام آمدند و آسورا انتظار کرد و چون دیر آمد دلکنان شدند و چنانکه عادت مشافی پشت

منفرد خاطر کشته و اندیشه شدند موش سنگ پشت را غ راکه هر چند رنج باشد بر هوا بر رود و در حوالی بنگر تا آمورا بیح لری پشی

راغ مروانی بر آمور دو در شد بلا بست و دیو بر بوز باز آمد و یار ازا علام کرد زاغ و سنگ پشت موش را که درین جا به عرباید بخوان

at work; the most renowned of them was the famous Bihzad.

Iskander Sultan was succeeded as governor of Shiraz by Shah Ruk's son, Prince Fath Ali Ibrahim (1414–34). Like many of the rulers of this age he was deeply interested in manuscripts; he was noted as a calligrapher and was also a keen patron of miniature painting; a *Shah Nama* in the Bodleian (Ousley Add. 176) was probably done for him. Its date has been disputed, but Robinson points out that it could hardly have been done before about 1430.[1] It is characterized perhaps more by the lavishness of its decoration than by the intrinsic quality of the work, but the miniatures tell thanks to the simplicity and vividness of their composition, and the same is true of a *Zafar Nama* or *Life of Tamerlane* which was copied at Shiraz about 1436; its miniatures are now divided amongst several collections in the United States. The book itself had been completed some ten years earlier, and was to be copied subsequently on numerous occasions, usually on a rather large scale, which no doubt seemed suitable on account of the subject-matter. A number of other volumes, notably a *Shah Nama* of 1444 in the Bibliothèque Nationale (Supp. Pers. 494) and some pages at Cleveland are also typical of Shiraz in their bold colouring, command of movement, and, more especially, in the mastery of rather angular compositions that they show. Similar features continued to be typical of Shiraz work down to about 1480, and though in the later paintings the faces are often rather expressionless, the colour contrasts are invariably effective. A considerable number of Shiraz manuscripts done between 1440 and 1480 has come down to us.

After the middle of the century it becomes very difficult to distinguish between the work done at Herat from that of Shiraz, but there are a few features which may be singled out as characteristic of one school or the other. Thus at Shiraz the painters loved to fill up the margins or any other spare areas with script, foliage, and more especially with animals, while in the landscapes, mountains were usually depicted at either side of the composition with a cleft or valley down the centre; in the earlier work the backgrounds were usually gold, while later a superb lapis blue became general; the colouring, though brilliant and decorative, tended on the whole to be rather cold, well attuned to the rather angular

47. HERAT. Nasr Allah, '*Fables of Bidpai*', AD 1414

H*

character of the compositions. At Herat purely decorative details played a greater part, while the figures tended to be on a rather small scale; the colouring was warmer and the artists on the whole tended to be more experimental and adventurous. Later the hard, angular rocks typical of the Shiraz landscapes tended to become soft and sponge-like.

If Shah Rukh was the principal figure at Herat and Iskander Sultan at Shiraz, the role of both of them as a patron was probably surpassed by Baysunqhur, one of the former's sons, who died somewhat prematurely in 1433. He appears to have been drunken and dissipated, and to have played a role of but little consequence in the affairs of state. His activity as a patron, however, was extensive. It began in Shiraz, and an Anthology now at Berlin was produced for him there in 1420 (B.W.G. 45). But very soon thereafter he had founded a great library and established a school at Herat, drawing painters and calligraphers from all parts of Persia to work in it. One of the former, Nasr Allah by name, illustrated in 1414 a copy of the *Fables of Bidpai* (*Kalila wa Dimna*) now in the Gulistan Palace at Teheran (B.W.G. 44); it contains thirty miniatures and shows a keen observation of fact combined with great imaginative feeling. In many of the miniatures the delightful dream-world that the Persian painters were so adept at creating dominates, as in the lovely miniature of the raven, the tortoise and the deer (Plate 47), but the artist was perhaps at his best in some rather more expressive renderings of animals, like the bull, roaring lonely in a landscape, which is illustrated in colour by Basil Gray. There is a very similar copy of this book at Istanbul (Revan 1022), but though its illustrations are perhaps even more colourful, they lack something of the expressive vigour of those in the Gulistan volume.

A copy of the Gulistan now in the Chester Beatty collection (no. P. 119; B.G. 87) was also produced for Baysunqhur at Herat in 1429, and a magnificent *Shah Nama* was completed there three years later; it contains twenty three miniatures and is now also in the Gulistan Palace at Teheran (B.W.G. 49). A number of its miniatures have been published in colour in the large Unesco volume on Persian painting; we include one of the less familiar ones here, namely Faramuz mourning over the coffins of Rustem and Zawara his brother, the exquisite

48. HERAT. '*Shah Nama*', AD 1431

detail of which shows the manner of the period at its best (Plate 48). The curious inverted perspective of the coffins is also noteworthy. Attempts have been made to distinguish in this manuscript the hands of several painters, but to attempt to do this is really fruitless, for the miniatures were clearly the result of a workshop collaboration, where the style of any single individual was subordinated to an overruling masterly design. How far the director of the school, Jafar al-Tabrizi, was himself responsible it is hard to say, though in view of the importance of his position and the outstanding quality of the manuscript it would seem likely that it was he who was primarily responsible. The compositions are throughout clear and effective though the faces are not always very expressive.

In addition to the director of the school there were several other painters of real genius working at Herat at the time, not the least important of whom was Ghiyath al Din, the only one of them, apart from Nasr Allah, whom we know by name. Three delightful paintings on silk, now in the Metropolitan, at Boston and in the Jane collection respectively, have been associated with him and it is even possible that he was responsible for one of the most lovely of all Persian paintings, namely a single leaf now in the Musée des Arts Decoratifs in Paris, though it has also been attributed to the painter of the Gulistan *Shah Nama* of 1429. On it is depicted the arrival of Humay in the garden of the Emperor of China where he meets the Princess Humayun (Plate 49). The flowers and trees are all in full bloom, and the whole picture is a riot of gay colour; the fact that the meeting took place at night is indicated only by the golden stars in the deep blue sky. There is nothing particularly Chinese about it, though Ghiyath actually visited China between 1420 and 1424 and left an account of his journey which attests his keen powers of observation and his interest in visual detail.

Another outstanding work of this age is a *Shah Nama* belonging to the Royal Asiatic Society, now housed in the British Museum, which contains a large number of very beautiful and very expressive miniatures, not the least of which is that depicting a group of Paladins who sit pensively by a pool while a great snowstorm that was eventually to engulf them builds up in the sky behind them. The clouds follow the con-

ventional Chinese pattern which had by now become universal in Persian painting, yet they are full of foreboding and seem somehow to embody the atmosphere of cold and silence which accompanies a heavy fall of snow (Plate 60). The manuscript is to be dated to about 1440 and it was perhaps illustrated at Shiraz for it has been associated with the name of Mohammad Juki, another of the great patrons of the period, who was resident there, but there is little to distinguish it from a product of Herat, and it heralds the style of the next generation there, when one extremely outstanding individual played a controlling role, namely Bihzad. After about 1450, indeed, the Herat school was dominated by him, and the story of painting there becomes to a great extent the story of the works of a few individuals who were to a greater or lesser extent under the influence of the one great man.

Though Shiraz and Herat were undoubtedly the most important centres, painters were also working in other places. Samarkhand certainly remained important even after Timur's death, and there is a copy of Nizami's poems at Princeton (Hitti, 7), dated 1446, which was done at Abarguh. Robinson assigns it to what he calls the Turkoman school. This came into existence under the patronage of the Kara Koyunlu or Black Sheep Turkomans, whose capital was at Baghdad from 1411 till 1433, and then at Tabriz till 1453, when they were conquered by the Aq Koyunlu or White Sheep Turkomans under Uzun Hassan. A volume of history dated 1438, now in the Bibliothèque Nationale (Supp. Pers. 206), was produced for one of the former, Jahan Shah (1437–67), who built the lovely Blue Mosque at Tabriz, and an anthology in the British Museum (Add. 16, 561) was done for Uzun Hassan in 1468. Its paintings are very brilliant and clear, even if the handling is rather hard, though the miniature on f. 60r represents a particularly delightful view of a harbour with a city below it (Plate 51). It is in a much more realist manner than that in evidence in the miniatures which dominated at Shiraz and Herat. Robinson assigns the Paris volume to his early Shiraz group and the latter to what he terms the 'Provincial Group', and lists quite a number of other manuscripts as belonging to the Turkoman school, but the fact remains that the two manuscripts were both done for Turkoman patrons. Uzun Hassan

49. HERAT. Ghiyath al Din (attrib.), c.AD 1430

50. SHIRAZ. *'Shah Nama'*, c.AD 1440

appears to have assembled a considerable number of manu-
scripts at Tabriz, and it has been suggested that many of them
were eventually taken to Turkey and dismembered, to be
mounted up in the famous Saray albums.

Though it is possible that a more realist, more forceful style
characterized the work done at Tabriz, it is not always
possible to be sure what was done there on the basis of stylistic
evidence alone, and it is clear that artists moved about very
freely. This is indicated not only by the close similarity of a
number of Shiraz and Herat manuscripts, but also by the fact
that a man from Tabriz, Jafar al Tabrizi, acted as director of
Baysunghur's school at Herat, while another, Mir Sayyid
Ahmad, was the reputed master under whom Bihzad learnt.
A third man is also known by name at this time, Ruh Allah
Mirak Naqqash, but we know little of his work.

At his death Shah Rukh left behind a library of considerable
size which contained not only a great many earlier manu-
scripts but also many contemporary ones which were in their
turn to become the models for later copies and to set a new
tradition of excellence. So fine were they, indeed, that the later
copyists often sought to reproduce them as exactly as possible,
without variation, and the exactitude of copying has some-
times led to confusion with regard to dating. But that does not
mean that the fountain had dried up with the deaths of Shah
Rukh and Baysunqhur, for a yet more glorious age was to
follow in due course, even if at first a phase of disruption and
confusion reigned in the political sphere. But towards the end
of the third quarter of the century firm control was restored,
and the production of work of a high artistic character began
again under the patronage of Sultan Husayn Mirza, or Bay-
qara as he was also known (1468–1506), and of his able and
cultured minister Mir Ali Shir Navai (1440–1501). The
former was indeed an almost exact contemporary of the
greatest of all Persian painters, Bihzad, whose earliest firmly
dated work is probably a miniature in a copy of the Gulistan
of Hafiz in the Rothschild collection which is dated 1486.

Bihzad was born at Herat around 1450 and died at Tabriz
about 1536; from 1468 till 1506 he was at the Herat Academy,
but with the rise of a new dynasty at that time and the trans-
ference of the capital to Tabriz he was summoned thither and

in 1522 he was put in charge of the Academy. He was the most revered artist of all Persia. It is recorded that a painter called Mirak – not to be confused with the artist of that name who was one of Bihzad's followers – was not only his master, but also his friend and protector; his name is connected with a copy of the Khamsa of Amir Khusrau of Delhi, now in the Chester Beatty collection (no. P. 163), but otherwise little is known of him. It is dated 1485. By this time Bihzad appears to have been about thirty-five years of age. But he had apparently made his name quickly and it seems likely that his earlier works remained unsigned and he only began to put his name to them when his reputation had been firmly established. Even then, except on one miniature in a copy of Sadi's Bustan at Cairo, where his name formed part of an impressive inscription, he signed in very minute writing in the most inconspicuous of places, modestly calling himself 'the humble slave Bihzad'. Many of his works even then would appear to have remained unsigned if modern attributions made on the evidence of style are to be accepted. But collectors even in his own lifetime began to take it on themselves to add his name to works to which they attached special value. In some cases these attributions were no doubt correct, but in others the name was intended either simply as a guarantee of high quality, or was added in the hope that it would increase the financial value of the work concerned. Furthermore, as there is evidence to suggest that Bihzad made considerable use of assistants, the problem of attribution is a very complicated one.

A whole series of portraits which have at one time or another been attributed to Bihzad tend to fall into the doubtful category, for they are not by any means all of the same quality and are not all to be accepted as by his hand. They comprise several of Sultan Husayn Mirza, notably a drawing at Boston and a double portrait forming the frontispiece of the Cairo Bustan of 1488, showing the Sultan in a garden; both may probably be accepted, though another double portrait in the Gulistan Palace at Teheran, dated 1485, is less certain. Uncertain again is another portrait of Husayn Mirza in the Cartier collection (B.W.G. 88) first published by M. Sakisian; it is probably to be dated about 1507. A portrait of a youth, one of a horseman, and several variants of a study of a youth-

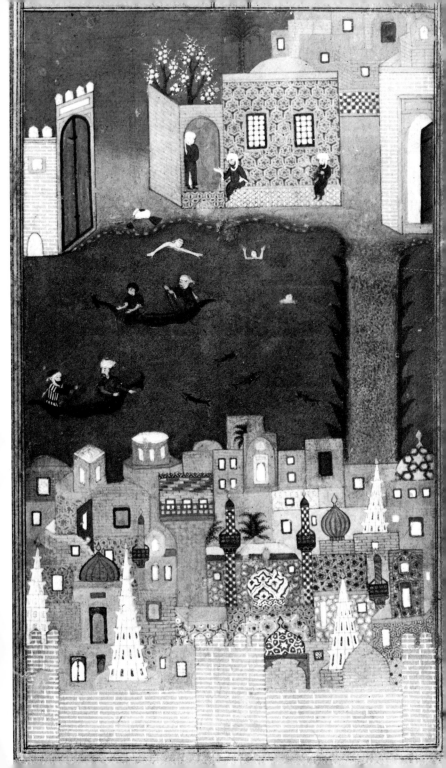

51. TABRIZ. *Anthology*, AD 1468
52(a) & (b) HERAT/TABRIZ. *Portraits in the manner of Bihzad* (1450–1536)

ful prisoner confined in a wooden frame like a set of stocks
are again all somewhat doubtful, while the portrait of a young
man painting, which is in the Freer Gallery (Plate 52a) said
to be a copy by Bihzad of a painting by Bellini, cannot be
accepted as such; it is possessed of more originality than the
average copy and is perhaps to be assigned to a Turkish
artist. Bihzad was undoubtedly famed as a portraitist, even
if Sultan Babur could write at the turn of the century that
'Bihzad's art was very delicate though he did not paint beard-
less faces well. He drew bearded faces admirably.' A drawing
lent to the Persian exhibition in London in 1931 (no. 372)
serves to prove the latter statement even if one can hardly
accept the former (Plate 52b).

Of the illuminations on a fuller scale, where a story is told,
there are some particularly delightful ones in a copy of Sadi's
Bustan in the Chester Beatty Collection (no. 156). One of
them is especially enchanting; it depicts a boat which had set
sail before one of the would-be passengers, a sage, could em-
bark; he followed the boat on his prayer mat, which trans-
ported him safely to his destination (f. 73v; Plate 53). There
is a colophon to the manuscript which gives the date 1478 and
assigns the miniatures to Bihzad and there is little reason to
doubt this attribution.

Of the works that are actually signed by Bihzad the most
important of the earlier ones are four miniatures in another
copy of Sadi's Bustan, in the Bibliothèque Egyptienne at
Cairo (B.W.G. 83); they were done for Sultan Husayn
Mirza in 1488. They comprise a scene where an old man is
refused admittance to a mosque, one of theologians disputing,
one of King Dara and his herdsmen (Plate 54) and one of
Joseph flying from the temptations of Zulaykha (Plate 55).[2]
All show the mastery of detail, the command of expression, the
brilliance of colour and the superb balance of composition
that characterize the master's work. The way in which
Zulaykha clutches at Joseph is done with great humour and
the rendering of the complicated architecture of the palace is
most interesting. The scene of King Dara and his herdsman is
full of imagination and is especially delightful; it illustrates
to the full the genius of the painter. On the whole he preferred
scenes of everyday life, where the day-to-day activities of
ordinary people could be portrayed.

Slightly later in date are three miniatures added to an older copy of the Khamsa of Nizami in the British Museum (Add. 25,900); all three of them are signed and were done, soon after 1490. They are small in size and very exquisite in character. They depict a battle scene with camels (f. 121v), Bahram slaying a dragon (f. 161r), and another battle (f. 231v). They represent the most delicate aspect of Bihzad's work, and are less angular, less severe than were some of his later miniatures, notably those in the Zafar Nama in the Garrett collection (see below). There are nine other fine miniatures in the same volume which are closely similar; some may be by pupils or assistants, but in the opinion of Binyon, Wilkinson and Gray two of them are to be regarded as the work of the master himself. One depicts Majnun in the desert (f. 130v; Plate 56a) and the other the Kaba at Mecca (f. 114v; Plate 56b), the latter is made particularly effective by its striking and unusual colouring. All of them represent Bihzad's mature style and may be contrasted with the miniatures in the copy of Sadi's Bustan in the Chester Beatty collection (Plate 53) mentioned above. The differences in style between the Chester Beatty and the British Museum manuscripts must be attributed to period, the latter representing his later manner. But even when his style was developed Bihzad was capable of working in several different manners, so that it is hard to date his work on the evidence of style alone.

Another series of miniatures which are not signed but which are of particularly high quality are those in the *Zafar Nama*, the *Life of Timur*, in the Garrett collection at Princeton. The book they illustrate was produced in 1467, but the miniatures were added later, perhaps about 1490. They have been published in full by Sir Thomas Arnold. He had no doubts as to their authorship, but others have questioned his attribution of them to Bihzad. The details have been somewhat affected by restoration, and they were in any case more monumental and less exquisite than much of his work, but the compositions are so forceful and so imaginative that they make of these pictures some of the grandest of all the paintings of the period. If they are not to be assigned to Bihzad, they must be regarded as the work of an unknown painter of equal genius.

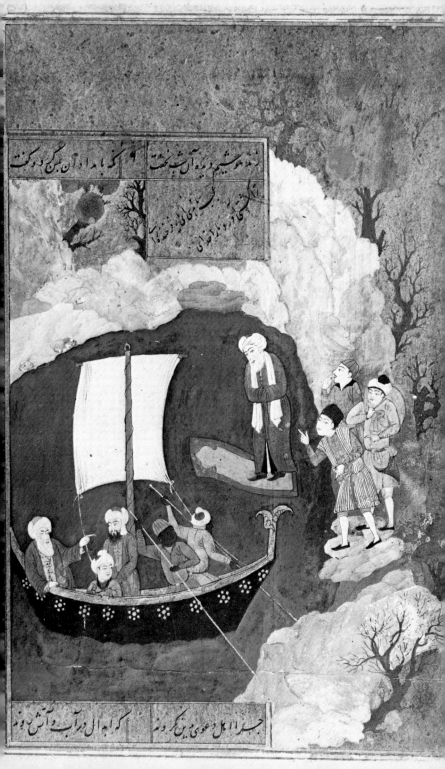

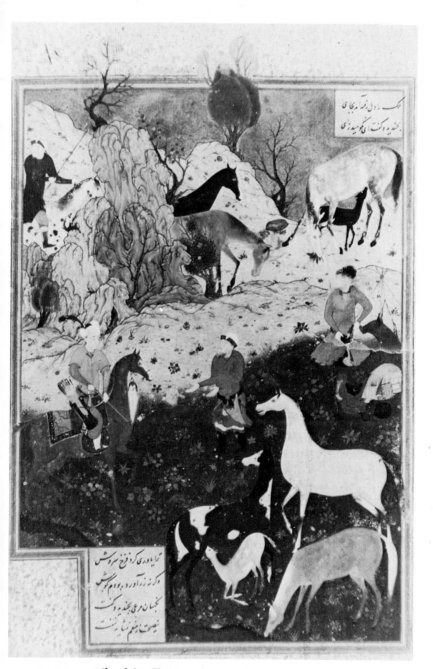

53. HERAT. Bihzad, '*Sadi's Bustan*', AD 1478

54. HERAT. Bihzad, '*Sadi's Bustan*', AD 1488

Opinions as to what other paintings should be attributed to the master, especially during his early years at Herat, vary considerably. Of the miniatures in another copy of Nizami's *Khamsa* in the British Museum (Or. 6180), which is dated to 1494, two are certainly by Bihzad; one depicts the building of the castle of Khwarnaq (f. 154v; Plate 57) and the other a visit by the caliph, Mamun, to a Turkish bath (f. 27v). Both are similar in style to the miniatures in the Princeton *Zafar Nama* and show the same interest in angular compositions. Several other miniatures in the same volume – there are twenty in all – have been associated with Bihzad, but their authorship is far from certain; one showing Bahram slaying a dragon (f. 157) is thus surely by a different hand (Plate 58). Sakisian would attribute many of them to a painter called Qasim Ali, on the basis of the similarity of inscriptions adjacent to the miniatures to those on a manuscript in the Bodleian (Elliot 339) which can be firmly assigned to Qasim Ali; one of them shows mystics discussing in a garden (f. 95; Plate 59). Basil Gray however may be right when he attributes to Bihzad the miniatures depicting Majnun at school and the death of Laila's husband (B.G. 122, 123).

Opinions as to the importance of Qasim Ali's work vary, for some have regarded him as the peer of Bihzad, whereas others, notably Kuehnel, think that he was little more than a gifted copyist. Most of the miniatures in the volume in the Bodleian follow those of the Cairo *Bustan* very closely, so that the suggestion that he was not very original may be accepted, even if the exquisite quality of painting marks him out as more than the mediocre figure of Kuehnel's estimate.

Herat was conquered by the Uzbeg, Shaybani Khan, in 1507, but at first the change of ruler probably had little effect on the lives of Bihzad and the other artists who were working there, for Shaybani Khan was also a keen patron of the arts. It was probably at this time that his portrait, attributed to Bihzad, was done. But the Khan survived for only three years, when he was in turn conquered by Shah Ismail of Tabriz. A number of painters had probably already left Herat for Tabriz before this event; others seem to have moved to Tabriz soon after, though many remained in Herat. The future of those who moved to Tabriz was soon to meet with another vicissi-

55. HERAT. Bihzad, '*Sadi's Bustan*', AD 1488

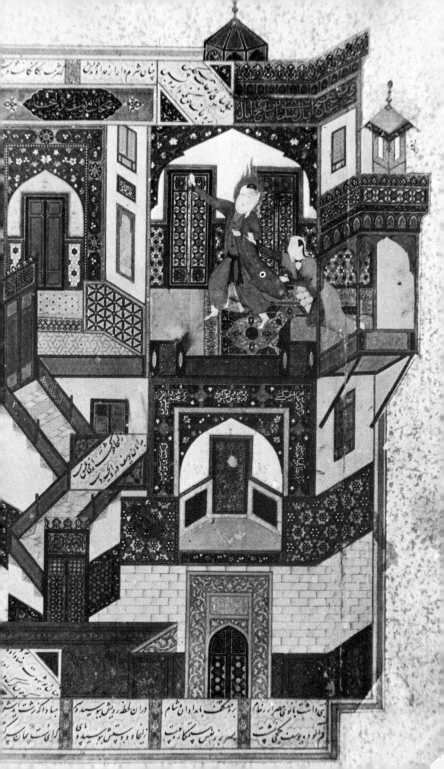

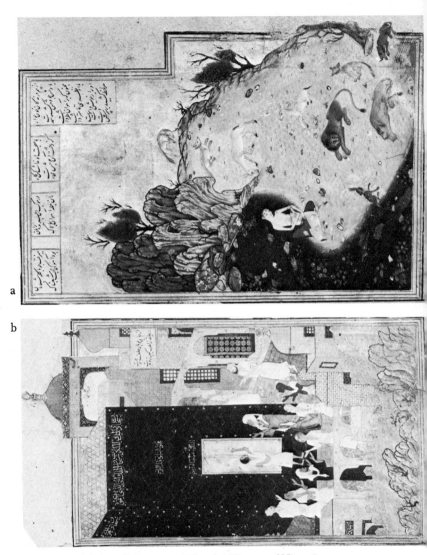

56 (a) & (b) HERAT. Bihzad, '*Khamsa of Niẓami*', *c*.AD 1490

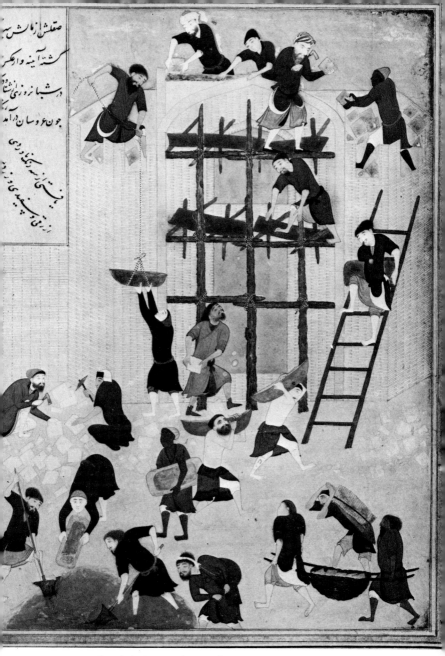

57. HERAT. Bihzad, '*Khamsa of Niẓami*', AD 1494

I

tude, for in 1514 Tabriz was captured by the Ottoman Turk, Sultan Selim. Bihzad, who seems to have already reached Tabriz, was kept in hiding during Selim's brief occupation; other painters fared less well, for some were taken back to Constantinople by the Turks, along with a number of the products of their work. Thereafter there seems to have been a good deal of exchange between Herat and Tabriz and it has been suggested that the illustrations to a copy of the *Diwan* of Mir Ali Shir Nevai, now in the Bibliothèque Nationale (Supp. Turc 316), which was written at Herat in 1526, were done partly in one city and partly in the other. One of its miniatures, illustrating the love of the Shaykh of Sanaa for a Christian girl, may perhaps even have been actually done by Bihzad himself and others have been attributed to the painter Shaykh Zadeh. The colours are light, and there is a stress on rhythmic movement which distinguishes the work from that done earlier. Another, and one of the most attractive of its miniatures, depicts Iskander shooting a duck in flight (f. 447v; Plate 60). He is seated on an enormous throne in a small boat without sail or oars; there are two more practical boats in the foreground, but their occupants pay no attention to Iskander's activities. A fine copy of Nizami's Khamsa in the Metropolitan, dated to 1524, continues in the style of Herat, and a number of other works are in the same manner, though most of them are not of the finest quality; the figures often tend to be rather wooden in spite of the very delightful colouring.

We do not know very much about the later years of Bizhad's life. In 1522 he was appointed director of the Royal Library at Tabriz, and when Shah Ismail died in 1524 his successor, the young Shah Thamasp, also accorded him favours. He lived on till about 1536, but there are very few miniatures of the later Tabriz period that can be attributed to him with any high degree of probability. The most important exception is a single miniature depicting an old man and a youth in a meadow, bound up in a manuscript dated 1524, containing specimens of calligraphy. The miniature was identified as a late work of Bihzad at the Persian exhibition at Burlington House in 1931 (B.W.G. 131). It is on a very small scale, and quite exquisite, though the line is perhaps not as sure as it was in work of the Herat period. A painting of two

camels fighting, now in the Gulistan Museum at Teheran and dated about 1525, has also been assigned to Bihzad's late years (Plate 61, p. 180). The composition is severe and rather formal, like those of the Princeton *Zafar Nama* and the attribution should stand or fall with that of the *Zafar Nama* illustrations. A drawing in the Louvre, depicting Shah Thamasp on a platform, set in a tree, also bears an inscription referring to Bihzad, but the attribution is somewhat doubtful. It is to be dated to about 1528.

All through these years of Herat's ascendency, work had probably continued to be produced at Samarkhand, though the city had faded well nigh into insignificance by the middle of the century. On the other hand Bukhara retained a considerable degree of importance as a centre of art and in the middle of the sixteenth century was regarded as very active. Its school was perhaps not as significant as had been that of Herat, and was certainly not as progressive as that of Tabriz in the first half of the sixteenth century, but work of real charm, distinguished by very effective but simple colouring, was done there under the patronage of the Uzbeg sultans. The absence of the Safavi stick turban and a mannerism of painting women with heads bent forward at a severe angle help to distinguish its products during the sixteenth century.

The principal figure there was Mahmud Muzahhib who, together with his pupil Abd Allah, signed miniatures now in an album belonging to the Mashad shrine. Both of them had been the pupils of Bihzad at Herat. Muzahhib developed a rather more independent style at Bukhara, using very luminous colours. He remained there till his death, the main figure in a school which was still active until around 1560, as we know from a copy of Sadi's *Bustan*, in the Bibliothèque Nationale (Supp. Pers. 1187), which was produced at Bukhara in 1556.

In addition to the schools of Turkestan work was being done in several other places, though most of it was very provincial in character. An Anthology in the British Museum, dated 1468 (Add. 16,561), was copied at Shirwan, a *Shah Nama*, formerly at Dunimarle in Scotland, was done in 1446 in Mazanderan, and a manuscript of Amir Khosrau Dihlawi's *Khamsa*, in the Metropolitan Museum, was written and pre-

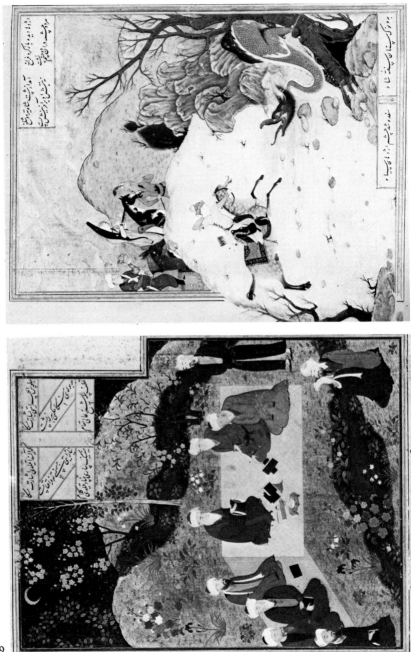

58

59

58. HERAT. Qasim Ali (?), '*Khamsa of Niẓami*', AD 1494

59. HERAT. Qasim Ali, '*Sadi's Bustan*', c.1495

60. HERAT/TABRIZ. Shaykh Zadeh, '*Diwan of Mir Ali Shir Nevai*', AD 1526

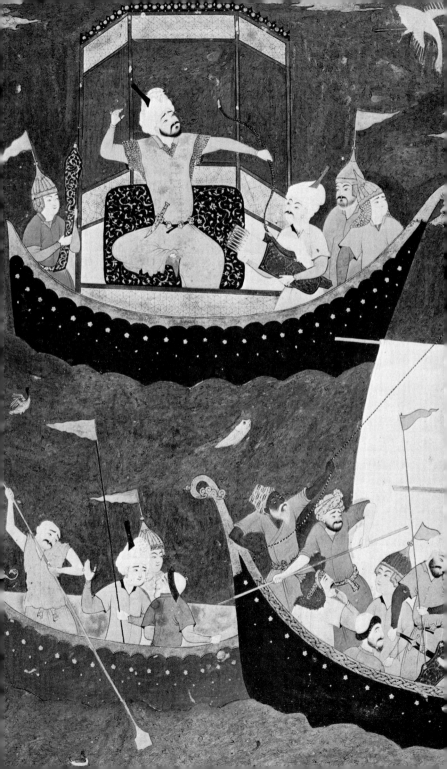

sumably also illustrated at Balkh (B.W.G. 120). We know nothing more about the school of Balkh, though it must have flourished till a rather later date, when a number of Tabriz painters were taken into the service of the great Moghul emperors who controlled that region as well as India.

In a similar way the removal of so many leading painters to Tabriz and the absence of Royal patrons did not imply an end to the Shiraz school, and quite a number of well known calligraphers and talented illuminators continued to work there till the end of the sixteenth century, producing competent though rather conservative work. These late paintings are characterized by an immense profusion of detail and by a particular disposition of the subject matter, the horizon usually being about two-thirds of the way up the picture; in the previous century it was placed near the middle. In addition certain other features help to distinguish the Shiraz work of the sixteenth century. The edges of the hills were thus outlined in white, the ground was dotted with stones, flowers and small trees, banners, spears and so forth tended to project over the margins, rocks became more and more fantastic, sometimes even taking on the character of demons, carpets were adorned with small-scale floral patterns, and the eyes of the figures were drawn with heavy black lines above and below. After about 1560 the style tended to become stereotyped and eclectic, the repertory of trees, flowers and rocks became no more than a convention; little that was truly creative was done at Shiraz thereafter. But there is one really outstanding Shiraz manuscript of this later phase, a copy of Qazwini's *Wonders of Creation*, in the Chester Beatty library (P. 212), containing over six hundred illustrations by a Shiraz painter called Attar; it is dated 1545. It is a veritable wonder for its sustained variety and imaginative creative powers, and represents the ultimate degree of fantasy that the Persian landscape could attain.

[1] *Descriptive Catalogue of the Persian Paintings*, p. 16.
[2] Coloured reproductions are given by Mohammad Mustafa, *Miniatures of the School of Behzad in Cairo*, United Arab Republic, Ministry of Culture and National Guidance, Nd. c1959.

8

The Safavid Age

☙

The founder of the new, and this time truly Persian, Safavid dynasty was Shah Ismail who defeated the Uzbeg Shaybani Khan at Merv in 1510. This gave him control over most of Persia, though the regions to the north of the Oxus remained in Uzbeg hands. He ruled his empire from his capital, which had already been established at Tabriz in 1502, and there it remained till the latter part of the century when it was moved first to Qazwin and then to Isfahan. Shah Ismail was much concerned with affairs of state and with the establishment of his empire, and his recreations were more concerned with hunting than with art; nevertheless his library was large and its studios were well equipped with painters and calligraphers, many of whom had moved to Tabriz from Shiraz, Herat and elsewhere soon after the turn of the century. Shah Ismail's successor, Shah Thamasp, on the other hand, was himself a calligrapher and designer and it was thanks to his patronage, and to the artistic interests of those surrounding him, that the Safavid age rapidly became not only one of the most productive but also that which is today looked back to in Iran with the greatest affection and admiration.

Though there was no very marked break between the paintings of the Timurid school and those produced for patrons of the earlier Safavid age, a number of distinct features developed quite rapidly. Thus, with the opening of the second quarter of the century, a new type of turban became universal; it had twelve folds, denoting the twelve Shia Imams, and these were bound around a stick which protruded at the top; it was usually painted red and this gave the name Qizil Bash or Red Head to the head-dress and to those who wore it. And in addition to such purely concrete factors, stylistic changes took place also,

62. TABRIZ. Aga Mirak, '*Khamsa of Niẓami*', c.AD 1540

63. TABRIZ. Muzaffar Ali, '*Khamsa of Niẓami*', c.AD 1540

though these were more gradual in their effect. Thus in the illustrations of the old romances and poems a love of decoration for its own sake tended as time went on to supplant an interest in the drama of the story; this is to be seen in a copy of the Zafar Nama or Life of Timur, in the Gulistan Palace, which was completed in 1529 (B.G. 132, 133). The compositions are over-full, the landscapes have become too fantastic, and there is a general lack of definition in the composition which makes the illustrations seem very inadequate if they are compared with those of the earlier copy probably done by Bihzad (see p. 127). But at the same time it must be admitted that a new interest in people as individuals was growing at the same time, even if the faces were not always very characterful. On the one hand, this outlook affected the subject matter of the scenes, for as time went on more stress tended to be laid on the events of everyday life while, on the other, more and more attention was paid to the artists themselves, so that in the sixteenth century we know a considerable proportion of them by name. The patrons were, in fact, becoming more interested in the artists and the individual character of their work and less so in the tales that were illustrated; the paintings were valued as personal products, and a new stress was laid on drawings because they seemed more personal that the paintings. At the same time artists began to sign their works more obviously, a practice which should have been of considerable help to the art historian of today, had not imitators and forgers added the names of well-known men to works which were broadly in their style.

The new attitude towards names is admirably illustrated in a superb copy of Nizami's Khamsa in the British Museum (Or. 2265), done for Shah Thamasp between 1539 and 1543, for most of its miniatures are signed; otherwise they are conservative, for they are full of the drama of the stories that are illustrated. It is one of the finest books that were ever produced in Persia. It contains seventeen miniatures, the work of six different painters, all of them among the most outstanding of the day, and most of them followers or even pupils of Bihzad.

They must have been dominated by the painter called Aqa Mirak ,who was not only responsible for five of the miniatures, but whose style influenced the other painters very markedly, to such an extent indeed that it would not be easy to distinguish

v. Mir Sayyid Ali: Majnun in chains.
'*Khamsa of Niẓami*', c.AD 1540. See p. 142

the identity of all of them were most of their paintings not signed. One of those by Mirak, that showing the Shah and his Vizir Nushirwan listening to owls in a ruined palace at night (f. 15v) is perhaps the most delightful (Plate 62). The minister could understand the speech of birds and he reports that one of the owls is saying that if the Shah continued with his present policy, the owl would be able to offer a fine dowry of ruined palaces to his family. The painting illustrates very clearly not only the brilliance of Mirak's work but also his passionate interest in nature in its every detail, and also offers a pleasant gloss on the gentle way in which monarchs could be reproved in Iran. Mirak had been a pupil of Bihzad and something of the majesty of his master's work was inherited by him, along with an outstanding technical mastery.

An equal attention was paid to detail by Mir Sayyid Ali, to whom one of the miniatures in the book is attributed, but his work showed at the same time a new interest in actuality and his approach tended to be less heroic. His contribution depicts the well-loved scene where Majnun (Colour Plate v) is brought before Laila (f. 157v); typical of his attitude is the way in which a number of everyday events are included, such as a sheep being milked, a herdsman playing a flute, and a woman filling a water pot; these details have nothing to do with the story but they are delightful and attractive and serve to indicate that an interest in the actual was growing up at the time. Unlike many of the other painters of the early Safavid school who came to Tabriz in the wake of Bihzad, Mir Sayyid Ali was born there, but left while he was still comparatively young, going to work for the Moghul Emperor Humayun first at Kabul and then at Delhi. He thus became one of the principal founders of the Islamic school of painting in India; there he was responsible for a large painting on canvas now in the British Museum depicting the emperors and princesses of the House of Timur.

Mir Sayyid Ali is not to be confused with Mirza Ali who was responsible for two miniatures in the British Museum Nizami, the Portrait of Khosrau shown to Shirin, and Barbad playing music to Khosrau (f. 77v); both show a great love of decorative details, the architectural ornament, the textiles and so forth being rendered with loving care. There is a good deal less realism here than in the work of Mir Sayyid Ali. Mirza Ali

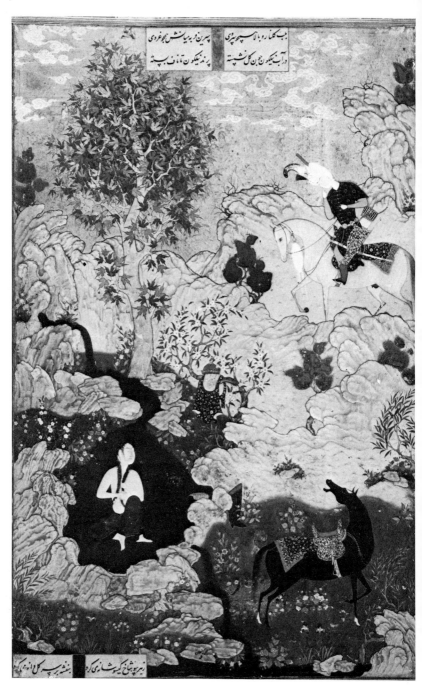

64. & 65. TABRIZ. Sultan Muhammad, '*Khamsa of Niẓamī*', c.AD1540

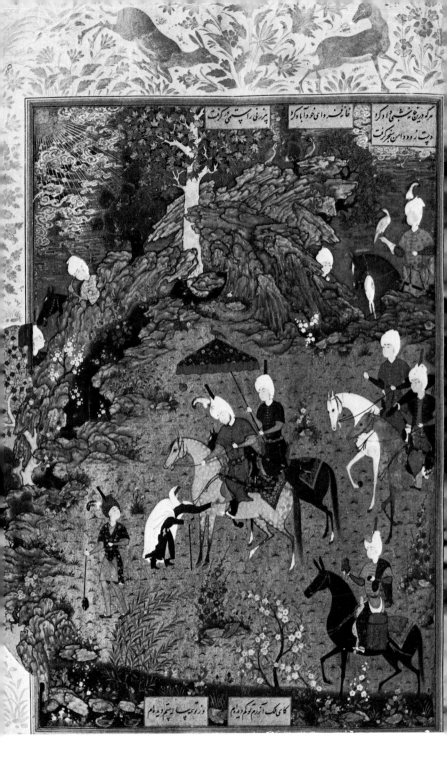

enjoyed great fame in his day, but we now know little about him and his work has at times even been confused with that of another painter called Muzaffar Ali, who did a lovely miniature of the traditional theme of the emperor Bahram hunting the wild ass (f. 202v; Plate 63), also in the British Museum Nizami. There is much less detail here and the somewhat over-crowded profusion of Mirza Ali's work is avoided. Muzaffar Ali was probably also a pupil of Bihzad, and he seems to have inherited something of his master's feeling for balanced and carefully thought out compositions, though his figures perhaps show greater movement than those of many of his contemporaries. Later in his life he appears to have done some wall paintings for the Chihil Sutun at Isfahan; the monumental character of his compositions made his work especially suitable for enlargement.

Another of the Nizami miniatures, that of Shirin bathing (f. 53v; Plate 64), is signed by Sultan Muhammad, and two others are probably to be attributed to him also; one depicts an old woman complaining to Sultan Sanjar (f. 18r; Plate 65), and the other the Ascent of Muhammad to heaven (f. 195r). He loved very ornate, decorative clouds and all three of these paintings are distinguished by their presence, especially that of the Ascent of the Prophet, where the clouds produce a veritable riot of movement in the sky. He also clearly loved animals and they are treated not only with affection, but also in a very decorative manner. On Bihzad's death he achieved great fame as the director of the Tabriz school and it was as the holder of this post that he gave lessons to the young Shah Thamasp. His directorship also had the consequence that thereafter more miniatures were attributed to him than he actually executed. But he seems to have been responsible for a drinking scene in a copy of the Diwan of Hafiz done for Sam Mirza about 1533, now in a private collection in the USA; it is a delightful and intimate work.

More powerful and forceful is a single miniature of a cavalry battle, in the Royal Scottish Museum at Edinburgh (Plate 66). It illustrates the grander and more impressive aspect of the work of this age, and is perhaps also to be attributed to Sultan Muhammad. It is to be dated to about 1540. It may be contrasted with an unsigned miniature showing two lovers entertained

by dancers, which is illustrated by Basil Gray (p. 137) or with the portrait of a young man done by the same painter about 1550 (Plate 67a), which is characteristic of the style that was to come into fashion in the second half of the century, and to reach its apogee in the work of Riza Abbasi in the seventeenth century (Plate 67b).

The British Museum Nizami provides us with a sort of gauge to the character of the early Safavid age, which under the youthful Shah Thamasp, was one of outstanding brilliance. If the greatest men were associated with the Royal library and were supported by the Shah, many others were involved on lesser enterprises or on work for individual patrons, and the output was very considerable. Of the painters of this category, a number, other than those who were involved in the British Museum Nizami, had come to Tabriz along with Bihzad, notably Shaykh Zadeh, who signed a miniature done for the Prince Sam Mirza in 1535; it is now in the Cartier collection (B.W.G. 127). He was also responsible for some of the miniatures in the great Rothschild Shah Nama done between 1527 and 1545 – there are more than 250 in the volume. It is one of the most magnificent books of the age and still awaits full publication. Other work has been attributed to him on stylistic or other grounds, notably all but one of the miniatures in a copy of Nizami's Khamsa in the Metropolitan Museum dated 1524/25, recently reproduced in full as a calendar (Plate 68). A painter called Khwaja Abd-al Aziz worked in a rather similar style; he is best known perhaps for the fact that he also gave lessons to the youthful Shah Thamasp. Another important figure was Shaykh Muhammad, who is not to be confused with Sultan Muhammad, though his work is rather similar; he seems to have been specially noted for his portraits, and there is an attractive one of a man with a flower at Boston. Some of his life seems to have been spent at Meshed, where an important minor school was established under the patronage of Ibrahim Mirza.

Sultan Muhammad was succeeded as director of the Tabiz school by Mir Naqqash; he was also noted as a portraitist, for by the time that he had reached maturity single miniatures were tending to become the vogue rather than illustrations to books, while brush drawings were also becoming extremely

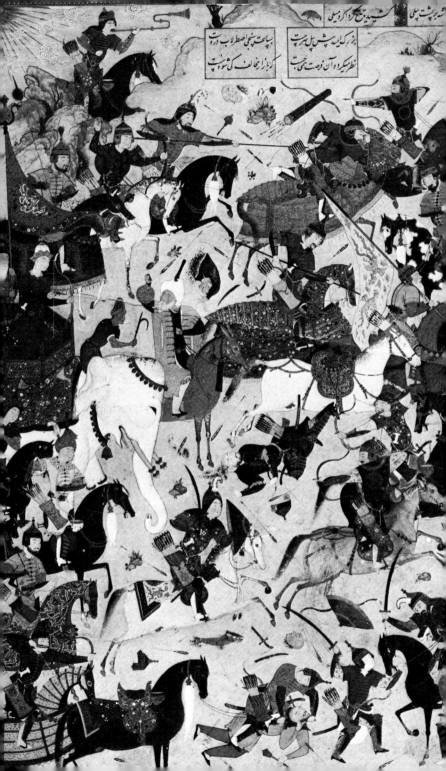

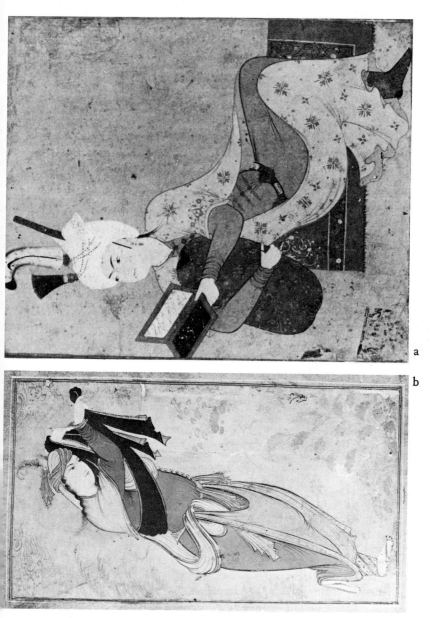

66. TABRIZ. Sultan Muhammad (?), *A cavalry battle, c.*AD 1545

67. TABRIZ. (a) Sultan Muhammad, *c.*AD 1550. (b) Riza Abbasi, 17th cent.

popular; an artist called Kamal of Tabriz was especially famed in this direction, while rather later Yunayat Allah from Isfahan was also producing good brush drawings in the Chinese style. Similar work was done by Shah Kuli, an artist who later on went to work in Turkey, as did Vali Jan, who won great fame in Istanbul for his portraits of young men and women in Turkish dress. More famous was Abd as Samad who, like Mir Sayyid Ali, went to India to work for Humayun; there he became the teacher of Akbar. He played a prominent part in the production of the immense Hamza Nama which was done there; it contained no less than 2,400 illustrations. A typically Persian fantasy which characterized his earlier work was forsaken in favour of a sterner realism after he was established in India.

The last of the great Tabriz painters was Muhammadi, son and pupil of Sultan Mohammad, and one of whose earliest works was a portrait of a prince, done at Tabriz in 1527, while one of his last was done at Herat in 1584. He, like most of the artists working in the second half of the century, was most concerned with single paintings, depicting individuals; one of the best known, at Boston, represents a pair of lovers; there is a very delightful drawing of his, now in the Louvre, of two oxen ploughing, dated 1578 (Plate 69), while a leaf showing a drinking party, at Boston, has also been assigned to his later years (B.G. 157). He was also one of the first important artists to concern himself with the ornamental lacquer bindings which were an important feature of later Safavid art.

The capital had been moved to Qazwin in 1548, but there are very few works that can be definitely associated with that city, probably because Shah Thamasp became very much of a recluse during the latter part of his reign, while the young Sam Mirza, who had also exercised an active role as a patron, fell into disgrace in 1561. Without the guiding enthusiasm of royal patronage progress was less marked than in the first part of the century, and it is virtually impossible to distinguish a separate Qazwini school, though Robinson cites a number of manuscripts that were illustrated at this time even if they were not actually done at Qazwin. All that can be said is that manuscripts produced after the end of the third quarter of the century tended to be less elaborate and less ambitious than those done before 1560. Single pictures tended to replace illustrated

volumes. Often they were of high quality, and serve to attest the competence of the artists; it was the urge of patronage to carry through lengthy, continuous productions that was lacking.

Shah Thamasp's successor, Ismail II (1576–8), did re-establish the library, but he only reigned for two years so that his efforts can have brought him but little reward. He was however succeeded by the famous Shah Abbas who reigned from 1587 until 1629, and it was under his leadership that the Safavid age attained its greatest distinction. The early years of his reign were by no means easy, for the government had become weak and his enemies powerful, and it was not really till the seventeenth century that he was able to give full attention to fostering the arts. In 1598 the capital was moved from Qazwin to Isfahan, and it was then that an age of unparalleled prosperity and progress began; Persia was opened up to the West and many new ideas were assimilated. Today the Persians look back on it as the phase of their greatest glory.

It must however be admitted that the quality of art at this time, taken as a whole, has been somewhat exaggerated. It is, much of it, an art of the boudoir, delicate, exquisite, delightful, but lacking in the real grandeur that characterized earlier ages. Shah Abbas' lovely mosques at Isfahan are a delight to the eye, but somehow their charm is rather superficial if they are com-pared with the great Masjid-i-Djami there, or with other of the outstanding foundations of the Seljuk period, and they some-how lack true architectural grandeur and originality; similarly the ceramics of the age can in no way compare with earlier products in respect of their creative genius: they mostly fol-lowed Chinese originals both as regards form and in their decoration. No great books were produced to compare in skill or originality with the Nizami in the British Museum of 1540 (Or. 2265) or the great Rothschild *Shah Nama*, while the single leaves, bearing elegant drawings of beautiful girls or charming youths, on tinted paper, though supremely well done, represent nevertheless an art of decadence in contrast with that of an earlier age; it has much in common with the work of an Aubrey Beardsley in the West. When the old tales were illustrated, as they often were, older compositions were copied carefully, with great skill, but without great creative genius,

68. TABRIZ. Shaykh Zadeh, '*Khamsa of Niẓami*', AD 1524

69. TABRIZ. Muhammadi, *drawing*, AD 1578

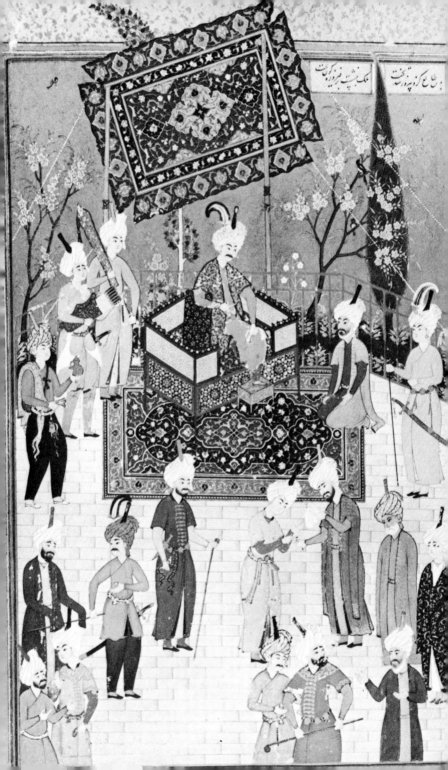

so that it is often very hard to date them, and were it not for certain external factors it would often be well nigh impossible to reach any reliable conclusion. But such features as changes in costume and fashion come to our aid. For instance, the turban with a high central spike which had been so popular in the reign of Shah Thamasp had gone out of fashion before the sixteenth century ended, and around 1560 very large, loosely tied turbans with frilly margins became usual, together with sheepskin hats. The latter remained in vogue till well on in the seventeenth century, but by about 1650 the large, loosely tied turbans gave way to smaller, firmer ones, with the end of the material projecting at the top. Stiff brocaded coats with a marked waist became fashionable at the same time.

So far as actual painting is concerned, the genius of the age is to be found in work on a rather modest scale. This is illustrated by the increasing popularity of drawings, which are distinguished by a mastery of line which has seldom been equalled; again, superb work was done in the field of textiles and designers, who should be classed as much more than mere craftsmen, were responsible for the exquisite silks and velvets, not to mention the carpets, which are to be counted among the finest Persian works of art of all time; and finally, in the sphere of painting, work in a new field became important, namely that of wall painting. We can read of wall paintings done at an earlier age, notably at Samarkhand, but only a very few fragmentary examples of the earlier works have survived, whereas those executed for Shah Abbas in the palaces of the Ali Kapu and the Chehil Sutun at Isfahan can actually be seen and admired, as can other work done elsewhere for individual rather than imperial patrons; some, in a charming little pavilion at Qazwin, now used as a museum, have only recently been cleaned. Their colours are delicate, the line elegant and if Western elements are to be traced here and there, the paintings still remain essentially Persian and are wholly characteristic of the age that produced them.

The fact that the two most important painters of the age both bore the name of Riza has led to a good deal of confusion, for their styles were closely similar and it is far from easy to distinguish the work of the one from that of the other; it has even been held that all the work was done by one man. And

the problem is further complicated because there seem to have been several other men of the same name working on manuscripts at much the same time. There was thus a calligrapher called Ali Riza, a painter called Aqa Riza-i-Murid, who worked in India though he came from Herat, and apparently another man called Riza who moved to Constantinople.

It would seem that the first Aqa Riza was active at a rather earlier date than Riza Abbasi, who was the most famous artist of the age; most of his work seems to have been produced before about 1616, for by then, if the historian Iskander Munshi is correct, he had virtually ceased to produce anything, though he was still alive. Basil Gray attributes paintings in the Bibliothèque Nationale and the Fogg Museum to him (B.G. 161, 162), and sixteen miniatures in a fine Shah Nama in the Chester Beatty Collection were also probably done by him, together with a considerable number of isolated drawings.

Riza Abbasi, on the other hand, was apparently born around 1575 and was active principally between 1589 and 1634. He was responsible for a large number of single pages during these years, most of them drawings. Dr Sarre was the first to isolate them as a group on the basis of a very distinctive type of signature; the list of attributions has more recently been examined by Professor Kuehnel in the *Survey of Persian Art* (p. 1886), and today Sarre's attributions are not all accepted. Nevertheless Riza's style was in a general way distinctive, and his work is characterized not only by the extraordinary delicacy of the line, but also by the penetrating nature of his portraits. Two pen drawings formerly in the Sarre collection may serve to illustrate the human understanding which permeated his work (Plate 70).

Riza's drawings rapidly became very popular, and his style was extensively copied. Many of the men who worked in this style were themselves very accomplished. Foremost among them was Riza's son, Muhammad Shafi or Shafi Abbasi as he was sometimes called, who not only worked in the manner of his father but also tried to pass his father's work off as his own and vice versa. His best work however was done under the patronage of Shah Abbas II (1642–67), when he worked mainly as a flower painter. He does not seem to have been affected by his patron's interest in Western art, for Shah Abbas sent painters

70. ISFAHAN. Riza Abbasi (1575–1634), *Two drawings*

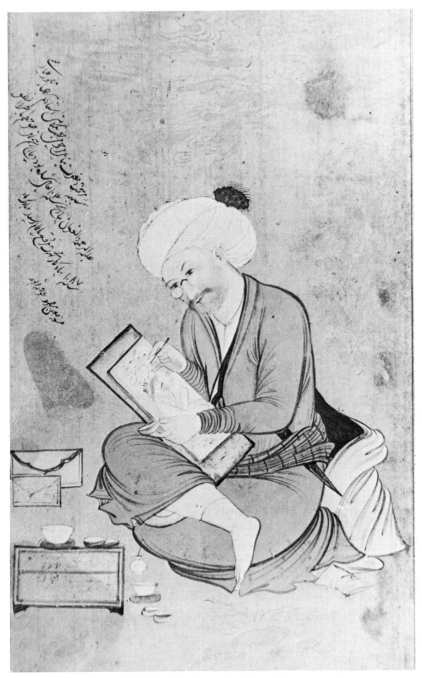

71. ISFAHAN. Muin Muzaffir, *Portrait of Riza Abbasi*, c.AD 1630

to the West and their works were responsible for considerable changes in Persian painting, which were to blossom in the following century.

Of the other followers of Riza Abbasi the most important were Afzal, Muhammad Yusuf, Muhammad Qasim, Muhammad Ali and Muin Muzaffir. The last was responsible for a delightful drawing of Riza Abbasi, described in an accompanying note as Muin's master; several versions of it are in existence (Plate 71). All of these men worked after, rather than before, the middle of the seventeenth century, when a passion for eroticism had begun to take serious hold, especially with regard to the drawings. But the old romances and poems still remained popular, though most of the illustrations that were done represent little more than hack work.

9

Painting in Turkey

☽

The study of Turkish painting is very much in its infancy.
Until recently it was regarded as no more than a rather feeble
offshoot of the Persian school, manifesting itself primarily in
the sixteenth and seventeenth centuries. Recent research,
however, has shown that work of real quality in a new and
wholly distinctive style was produced under the patronage of
the Ottoman sultans, and certain Turkish scholars have even
gone so far as to claim for Turkish art all sorts of works which
really fall into one or other of the clearly defined groups we
have already examined. They thus assign to the credit of Turkey
works like the Miraj Nama in the Bibliothèque Nationale
(Supp. Turc 190; see p. 109), done for Shah Rukh in 1436,
simply because its text is in Jagati, a Central Asian language of
Turkish character, while they again claim for Turkey such
works as the Edinburgh Rashid al Din because some of the
scribes and miniaturists who produced it were probably
Uighurs, that is to say men of Turkish speech. To claim such
works is to assess the claims of Turkey too universally, but the
copy of the Romance of Varka and Gulshah at Istanbul which
was mentioned in connection with the Mesopotamian school,
is indeed probably to be attributed to the Seljuks of Rum
(Plate 12), for figural work that is very similar appears on
ceramics from Kubadabad near Konya, and there is mention in
the texts that miniatures were done for the Anatolian Seljuks.[1]
The style of the Varka and Gulshah manuscript is broadly
akin to that of the 'Red Ground' Shah Namas, though the
mountainous backgrounds follow the same spiky convention
as those in the Edinburgh Rashid al Din, so attesting links
with Central Asia or China. A date towards the end of the
thirteenth century is likely.

Whether or not such works were executed for, or even by, Turkish-speaking patrons, the Turkish school proper does not really begin till after the establishment of Ottoman power at Istanbul in 1453, and it is to that phase that we will give our attention here.

The paintings of the Ottoman period can be conveniently considered under three heads, firstly, work in an essentially Persian manner; the style was introduced from Iran in the sixteenth century and was first practised by Persian masters who were brought to Turkey and subsequently taught a number of Turkish artists who continued to work in the same manner. Secondly, a distinctive and wholly realist narrative style stands out as something quite independent, though still related; the paintings of this group are concerned with recording the events of Ottoman history and daily life in a vivid, straightforward manner, without any of the poetic imagination or illusion of Persian painting. Thirdly an extremely expressive linear style was in favour for a short time, the work of one man or one restricted school. At times the products were almost grotesque; always they had the vividity of the best caricatures. All the examples we know have been found pasted into some of the famous albums in the Saray at Istanbul and more especially into one which has come to be known as the album of Fatih, the Conqueror (Top Kapi nos. 2152, 2153 and 2160). Work in this manner stands quite apart and it has even been queried whether it is Turkish and not perhaps Mongol or Central Asian.

Before dealing with the Turkish style proper – the theme which will form the main subject of this chapter – it will be best to say something of this expressive, violent style. There seems to have been one particularly outstanding exponent of this manner, a man known as Mehmet Siyah Kalem, that is, Mehmet the Black Pen. Professor Togan has identified him as a painter from Herat but there is really little evidence for this; nor, it would seem, was he the sole exponent of the style, for there appears to have been an active workshop engaged in the production of these vivid works over a period of at least a lifetime. The attributions to Siyah Kalem are made on the basis of inscriptions, but these are attributions rather than real signatures. The subject matter of the works attributed to Siyah

72. TURKEY. Mehmet Siyah Kalem, drawing, late 15th cent.

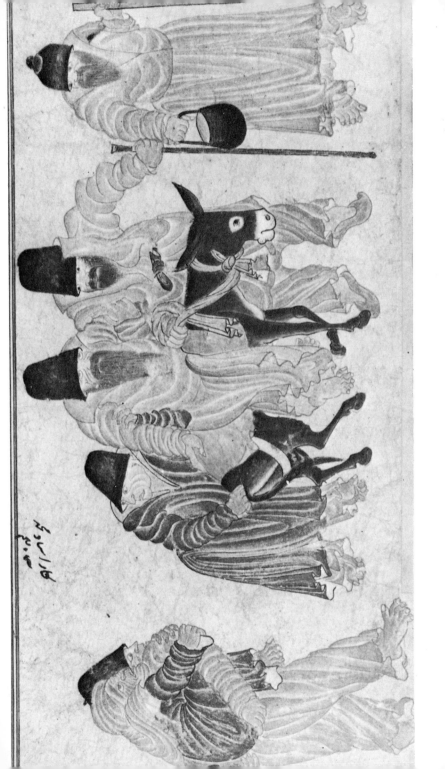

Kalem – expressive, highly dramatic and at times grotesque figures, animals of exceptional vigour and so forth – is very distinctive, but some other subjects, especially animals, which are probably by other hands, are nevertheless in the same general style (Plate 72). Several other names are known, notably Cheyki, Ahmet Oudi and Mahmut Shah, but it is not yet possible to differentiate between their work. The Chinese character of many of the figures, especially the demons, the Mongol costumes, the Far Eastern nature of the drawing, and the wild, uncivilized life that is depicted are all very distinctive; indeed these paintings differ from most other Islamic works in that they can hardly have been illustrations to a book or connected with any single narrative; rather they would seem to have sought to record life as it was lived in some rather primitive, nomad community.

The problem as to where these drawings were done still remains unsolved. It seems more likely that they were acquired from elsewhere by the compilers of the albums – whether or not it was done for Sultan Fatih – rather than that the artists actually worked for an individual Ottoman patron, for the whole spirit of the work savours of Central Asia rather than Asia Minor; in view of the fact that some of the figures would appear to be Shaman priests and not Moslems, it is even probable that the patron was a Mongol rather than a Turk. The regions of the southern Volga or the north Caspian littoral, or perhaps even Turkestan, have been suggested and the style has been termed the 'Kipchak', which would associate it with the first mentioned locality. But these proposals are no more than very tentative; what is sure is that the drawings have to do with the life of the steppe rather than with that of any more settled Islamic community. Though dates varying between the twelfth and the sixteenth century have at one time or another been suggested, a date in the later fifteenth century would seem most likely.

In complete opposition to this 'Kipchak' style is that which was introduced from Persia and was subsequently developed on Turkish soil – or rather one should say in a Turkish city; for although fine calligraphy was practised universally, the production of figural work was almost, if not entirely, concentrated in the capital at Istanbul. Persians had, apparently,

reached Istanbul even in the fifteenth century though no work that was produced there at so early a date has survived. After the Turkish conquest of Tabriz in 1514, however, a number of Persian painters were brought back; sixteen of them are actually noted in the texts, and mention of others who followed them is made in 1525 and 1527; one of them was called Shahkuli of Tabriz, and he was in Istanbul in 1525. But the most famous of them was Wali Jan, and he became court painter to the sultan in 1587. These men taught Turkish pupils and for a time a considerable quantity of work in the Persian manner was produced. But the imaginative dream-world of Persia was not really attuned to the Turkish outlook, and though they always enjoyed Persian literature and loved to see miniatures illustrating the old themes of the Shah Nama or the Persian poets, they soon got interested in other tales which were wholly Turkish and began to illustrate them in a rather new way. To the basically Persian elements in the paintings – exquisite trees in blossom, colourful costumes, intricately designed carpets, undulating backgrounds with people peering over the hills and so forth – were added a number of new, more realist elements, and the old love of poetic fantasy and illusion gave place to a more prosaic, everyday approach. At the same time the compositions became more formal, more angular, and the colouring rather harsher. Till recently it was the fashion to condemn the style as no more than a decadent version of the Persian. Today we recognize that the Turkish school is really something distinct, which must be judged on the basis of different criteria. Partly thanks to the publication of previously unknown material from the imperial collection in Top Kapi Saray at Istanbul and partly because of changes in taste, the qualities of this more angular, more realist manner have at last come to be recognized, and Turkish painting of the Ottoman period is now accepted in its own right. As Stchoukine puts it, there is no more reason to denigrate Turkish art because it took over a great deal from Persia than there is to disclaim Russian art because of its debt to Byzantium, or Japanese because of the numerous Chinese elements that are to be found in it.

There are a few concrete, easily defined features that serve to distinguish the Turkish works; the most obvious are the

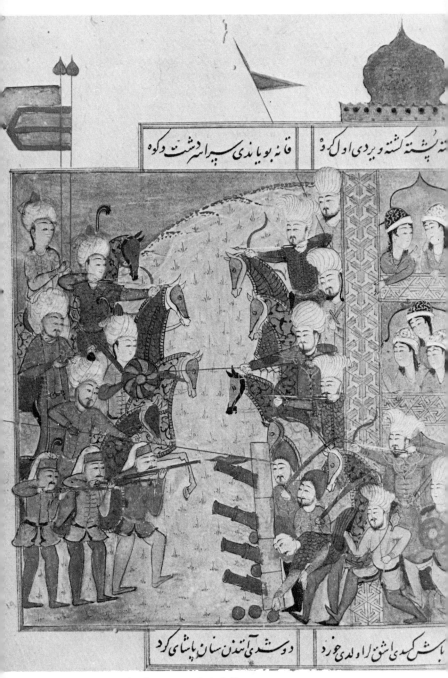

73. TURKEY. *'Selim Nama of Shukri'*, c.AD 1524

74. TURKEY. *'Suleyman Nama'*, AD 1558

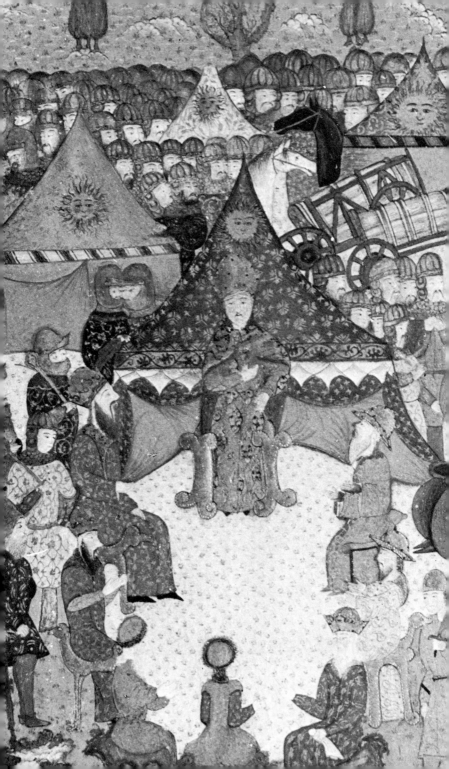

costumes. In the civilian sphere the large voluminous turbans of a type unknown in Persia are most striking, while long robes, quite distinct from the Persian ones, also came into vogue. Even more distinctive are the military uniforms, those of the Janissaries being recognizable at a glance. The faces again are clearly Turkish, the beards and moustaches of a different character from those favoured in Persia, while the colour schemes tend to be more brilliant, the general effect more metallic; the subtle nuances of the best Safavid work are lacking, but so too are its weaknesses, and the Turkish miniatures represent an essentially virile, masculine art, in opposition to the effeminate style that was in vogue in Persia. There is a hard, almost geometric, look about many of the paintings, the compositions being severe and angular and making great use of straight lines, both vertical and horizontal. Finally these works are distinguished by their subject matter; there are numerous new themes, for to the numberless subjects illustrating the old romances of Persia was added a well nigh limitless repertory of events and scenes from everyday life and from the events of contemporary history. And these were all done in a vivid, narrative manner. No Turkish artist was able to enter into the dream world of illusion in the way that the Persians had done so superbly; their outlook was more practical, but their work was none the less impressive and attractive.

Though it seems likely that work in the new style was done for Sultan Fatih, the Conqueror – indeed we know the name of one painter of the age, Sinan Bey (not to be confused with the more famous architect) – nothing of importance actually survives from before the reign of Suleyman the Magnificent (1520–66), whose patronage was responsible for the first and most brilliant period of Ottoman art. Several painters of the age are known by name, such as Osman and Haydar Reis, also called Nigari; numerous others remain anonymous, though their different styles are to be distinguished among the numerous illustrations of the great historical books which were so popular, like the Huner Nama – one done between 1550 and 1590 has 160 miniatures – and the Surnama, one of which contains no less than 427 illustrations.

The earliest of these historical books is the Selim Nama of Shukri (Top Kapi H. 1597/98), completed between 1521 and

1524 (Plate 73). In many ways it is still close to Persia – figures in the background peer over hills, some of the men wear stick-turbans of Safavid type, while the landscapes are dotted with small bushes – but the faces are truly Turkish, the soldiers wear Janissary uniforms, there is a predilection for vertical lines in the composition and also a realism wholly foreign to Persian art. These characteristics are carried a good deal further in many, though not in all, of the illustrations of the great Suleyman Nama of 1558 (Top Kapi H. 1517); a number of artists must have been engaged on this book, some working in a rather conservative style, like the man who did a scene of Suleyman hunting, while the work of others is almost exaggeratedly Turkish – for example the scenes where Suleyman directs the artillery in a battle – while one where Louis II of Hungary holds a council has been assigned by Stchoukine to a western painter, perhaps a Hungarian (Plate 74).

The characteristic angular Turkish style appears again in the Shah Nama of Selim Khan in the Top Kapi collection (H. 3595), written in 1570 (Plate 75). The costumes, the faces and the angular compositions are all essentially Turkish; the receding hills of the background, from behind which figures loom up, and the vegetation, attest the Persian heritage; though the realism of representation in such details as the boats, the architecture and the vigorous activity of those who participate in the everyday events, which play a prominent role in most of the miniatures of this manuscript, suggest that the painters – there were no doubt several men involved – must have given some attention to western art. Since the time of Fatih links with the west had been established; Gentile Bellini and other Italian painters had visited and worked in Turkey; a Turkish painter, Sinan Bay Naqqash, had worked in Venice, and he had been followed by others whose names we do not know; Nigari did copies of western portraits. The effect of these various links is clearly to be seen in many of the miniatures of this book.

The development of this realist style was carried even further in the reign of Murad III (1574–95) who, together with Suleyman the Magnificent, was probably the most active patron of all the sultans. The activities of the manuscript-makers were further intensified thanks to the development of a whole series of new themes, most of them the work of Loqman; outstanding

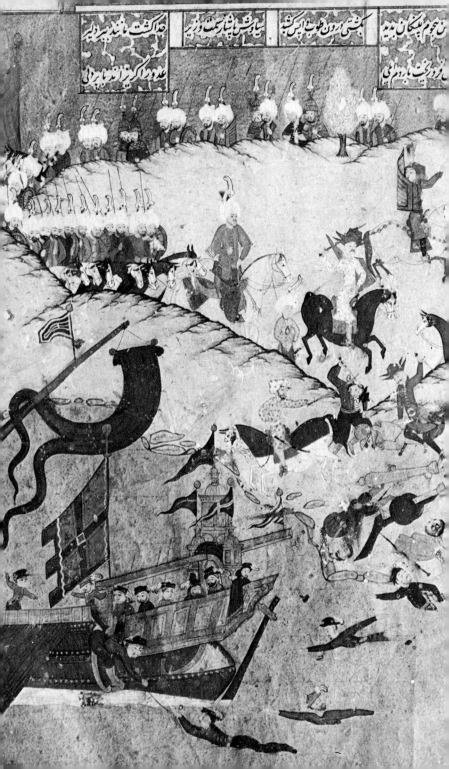

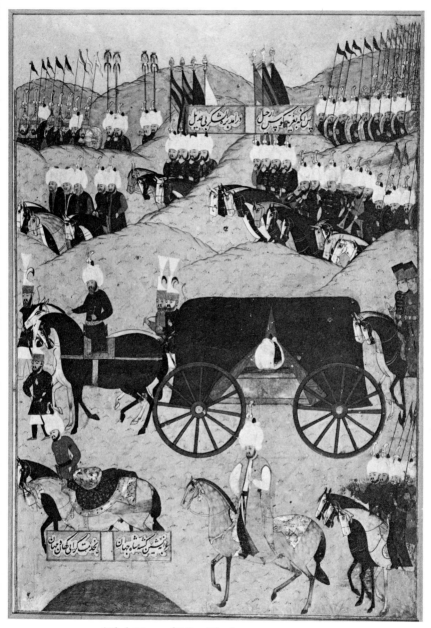

75. TURKEY. 'Shah Nama of Selim Khan', AD 1570

76. TURKEY. Loqman, 'Suleyman Nama', AD 1579

among them were his life of Suleyman, the Suleyman Nama, finished in 1579 (Chester Beatty Collection no. 413) and a Shah in Shah Nama (Yildiz 2652/260) of 1581. A great double-page depiction of the progress of the funeral procession of Suleyman in the former is especially fine and shows to the full all the characteristic Turkish elements, such as the magnificent uniforms, the angular compositions and the typically Turkish faces. The way in which the cavalry troops are grouped behind hills succeeds admirably in creating an impression of the countless mass of the troops and the endless nature of the procession.

Some of the most attractive work of the age, however, is probably to be found in the great Surnama-i-Humayun (Top Kapi H. 1344) completed around 1584, the 437 miniatures of which depict the various guilds and the members of the diverse professions processing through the At Maydan, the ancient Hippodrome, on the occasion of the feast of the circumcision of Mehmet, the son of Sultan Murat III (Frontispiece); the event was vividly described by Edward Webb, an English merchant of the Levant Company who was in Istanbul at the time. A Shah Nama of 1583, some leaves of which are now at Boston, is on the other hand in a basically Persian style and serves to show that the old manner persisted alongside the new until a quite late date.

Loqman was responsible in addition for a fine religious manuscript, the Zubdet al-Tawarikh, now in the Chester Beatty collection (No. 414); it contains a number of most interesting miniatures, some of them depicting Christian scenes such as Christ's Ascension; they are in a rather metallic, but also essentially monumental, style. A Hünernama in the Top Kapi Saray (H. 1523), which is also associated with him, on the other hand, contains a number of miniatures of an almost childish character, though they are not without a certain naïve charm. But among a number of artists who were involved in the production of this book, one, named Osman, was responsible for some miniatures of a much higher standard, notably one in the Hünernama of Loqman (Hazine no. 152, f. 162v), dated 1584, which shows Sultan Muhammad the Conqueror casting his mace at the serpent column in the Hippodrome; he seems to have succeeded in removing the lower jaw of one of its three heads, but the other two are intact (Plate 77); in the

numerous depictions of the column in the Surnama of 1582 the
heads are intact but for this one jaw; it would be interesting to
determine when exactly the heads were finally destroyed.

Osman was probably the greatest exponent of the art of
miniature painting at this time, but the truly Turkish style of
which he was so accomplished an exponent continued for long
after his death, even if, as time went on, it declined into a some-
what stereotyped narrative style. There was a revival under
Sultan Ahmet III, when another individual of outstanding
genius came to the fore whom we know as Leoni; his real name
was Abdul Celil Celebi, and he came from Edirne (Adrianople)
He was most famous for his female portraits and his studies of
girls; they are all in elegant, attractive attitudes, but their faces
lack expression and they all tend to follow a set model (Plate
78a). More effective, though less well known, are the 137 minia-
tures he did for a volume by the poet Vehbi which was pro-
duced on the occasion of the circumcision of Prince Suleyman,
the heir to the throne; especially notable are some enchanting
pictures of the great set-pieces of fireworks which played a
prominent part in the festivities.

A place half-way between Turkish realism and Persian
idealism must be accorded to the charming garden and land-
scape scenes which form an important vein of Turkish paint-
ing. The Turks were great lovers of nature and great gardeners
– the head of the gardeners of the Saray at Istanbul was one of
the most important and responsible court officials – and the
love of the gardens themselves reflects itself in the originality
and beauty of the garden paintings. Gardens appear some-
times, in the backgrounds of scenes of other types, and the
countryside in the Turkish paintings always has a rather garden-
like character, but every now and again the whole painting was
devoted to a landscape or garden scene. Stchoukine would in-
deed assign to Turkey the landscape paintings in an earlier
anthology of Persian origin (Türk ve Islam Müzesi, no. 1950)
which other authorities assign to Persia (see p. 104). The
elements of which its miniatures are composed – cypress trees,
cherry trees in blossom, scrolling leaves, hills and pools – are
all essentially Persian, but even though they are treated here in
a way which is wholly distinctive and original and shows much
of the formalism of Turkish art, a Persian provenance seems

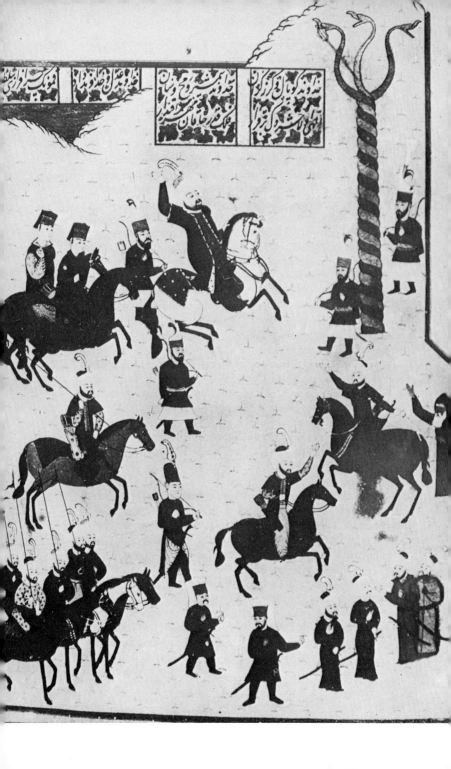

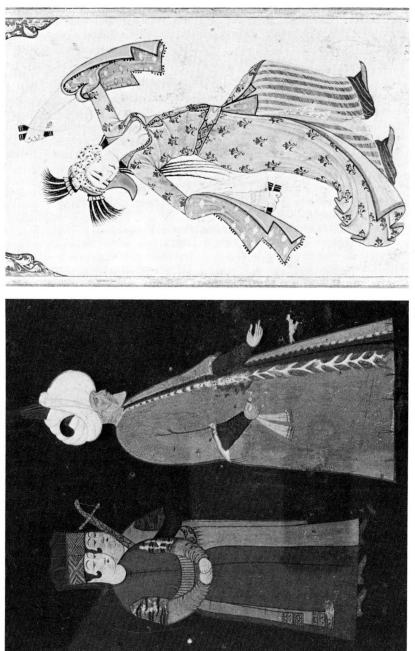

a

b

77. TURKEY. Osman, '*Huner Nama*', AD 1584

78. TURKEY. (a) Leoni, dancing girl (b) Nigari, Sultan Suleyman

more likely. The paintings can hardly be later than the early fifteenth century and Turkish art did not really begin to develop as an independent style till later. The Turkish illuminators also loved to draw maps and plans, and made of them things of great delight as well as great interest.

One final vein in which Turkish artists were especially effective must also be noted, namely portraiture. A number of isolated portraits are known, most of them of fairly early date. The individuals who appear on scenes, like those concerned with Suleyman the Magnificent's life in Loqman's *History*, would also seem to represent the actual persons with very precise accuracy. The Turkish painters, inspired perhaps by Gentile Bellini and other men from the west, avoided the depiction of a universal type, as was done in Persia, and sought rather to record the permanent basis of each individual face as accurately as possible; but they did not pay any attention to transitory elements or emotions, or indeed seek to convey character. No scowl, no smile, not even a wrinkle, appears, though such features as a great hooked nose or curled moustache would be rendered with the greatest faithfulness. A few of the most outstanding of these portraits may be mentioned, namely that of Fatih the Conqueror by the painter Sinan, those of Suleyman the Magnificent and Selim by Nigari (Reis Haydar) (Plate 78b) and that of Ahmet III by Leoni. Even in the last of these the expression of power was the main aim and in all of them the majesty and strength appertaining to great rulers are very clearly implied. Even figures other than the sultans were depicted as strong, forceful and virile, and they were usually shown in middle age; the elegant youths so popular in Persian art in the sixteenth century never appear in Turkey, though the attractive dancing girls so prominent in the work of Leoni certainly had a part to play.

The last phase of Turkish painting need not really concern us, for Western elements gradually began to play a more and more significant role, usually to the detriment of the Turkish style, and little was produced after the earlier seventeenth century that deserved to receive consideration in a book devoted to the study of Islamic painting, even if the oil paintings and portraits in the Western manner that became so popular in the nineteenth century have a certain naïf charm of their own.

[1] M. Ipsiroglu, *Painting and Culture of the Mongols*, London, 1965, figs. 1 and 2.

I O

Non-representational painting

☽

Finally, a word may be said on the subject of the non-figural decoration. This plays quite a significant part in the secular works but its role was of course even more important in the religious manuscripts, for there, all figural work was wholly avoided. These formal compositions constituted a very important aspect of Islamic art; indeed it is perhaps true to say that this was the only truly Islamic form of painting, for it was only in this sphere that a universal style was developed which embraced the whole of the Islamic world from Spain to India, and saw continuous development from the earliest times onwards. This does not mean however that there were not local variations, for after the twelfth century regional differences did become apparent, but they were variations within narrow bounds. A rather heavy style with deepish colouring thus distinguished Spain and North Africa; in Egypt the patterns were more varied and took on forms similar to those of the carved woodwork for which Egypt was renowned, while the Seljuks favoured a very angular type of decoration, similar to that used in their tilework and in the sculptures of the stone buildings of Asia Minor. Broadly, however, the distinctions were much less marked than those between say the work of the Mesopotamian and Ilkhanid schools in early times or the Safavid style of miniature painting in Persia and that of Ottoman Turkey at a later date.

In the earliest of the religious work that we know, done during the first two or three centuries of Islam, the main adornment of the Korans consisted of small bands of simple geometric pattern used to mark the end of a sura. With the third century the bands became more elaborate and began to occupy larger sections of the page. They were still horizontally disposed, and

79 (a) Early Kufit script, 9th cent.
(b) Ornamental title page, with script, AD 1306

80 (a) '*Khamsi of Niẓami*', ornamental title page, *c.*AD 1490
(b) '*Khamsi of Niẓami*', calligraphic ornament, AD 1410

in the more important places took the form of tabula with a tag or projection at one – or even sometimes at both ends – (Plate 79a). These tags survived on till a quite late date; one is there, for example, on a page dated 1306, which is now at Leipzig (Plate 79b). Usually the patterns were modelled on those inherited from Coptic and Hellenistic art, and often too they followed Byzantine models, such as the geometric pattern that frames the portraits on the title page of the famous Dioscorides manuscript now at Vienna, done for Juliana Anicia in 512.[1]

It was with the thirteenth century that the full exploitation of geometric motifs began and that the idea of filling a whole page with ornament of this type was conceived. First the disposition on the page was changed from horizontal to vertical so that first the central portion and then the whole leaf itself was adorned, the patterns being done in blue, red and gold. It was however not so much the colours as the intricacy of the patterns that served to distinguish these decorations from the artistic point of view. At much the same time the idea of treating the title page as a double-leaf composition was born, and on some of the very large Korans which were popular in the early years of the fourteenth century the title pages were of a truly monumental nature. Interlacing patterns of a rather angular character and a great variety of designs based on geometrical composition or circles were used: after the thirteenth century six pointed stars became especially popular. These motifs remained in vogue throughout the fourteenth century, though as time went on scrolling patterns tended to play a more and more important role.

With the fifteenth century the ornament tended to become more flowing and greater attention was paid to motifs of a naturalistic origin. At the same time the colours became rather more varied and more delicate and the lines thinner, scrolls and floral patterns coming to play a greater role. At this date parallels can be drawn with the designs on carpets and textiles rather than with those suitable to stone carving, woodwork or metal (Plate 80a). The delicate charm of these patterns was enhanced by the use of tinted paper, pale pink, pale green or deep cream being especially popular. In secular manuscripts animals and birds treated with a real feeling for naturalism were

introduced into the formal designs, but the adornment of the Korans remained wholly non-representational even when scrolls were included. At much the same time a practice of writing the text in different forms of script, disposed at different angles on the decorative title pages became popular, the lines of text being arranged horizontally, vertically and diagonally to intensify the decorative appeal. At the same time elaborate tables of contents were added, their very nature serving as a new and original basis for decoration, while script itself was exploited more and more fully for its decorative qualities (Plate 80b).

The role of calligraphy in itself falls outside the scope of this survey, but it must be remembered that in the Islamic world writing was treated as a major art, and that the actual script was regarded as a thing of beauty in itself, and this applied not only to the Korans, but also, in later times, to the secular books, where its arrangement in juxtaposition to the miniatures was of the greatest significance.

[1] D. Talbot Rice, *The Art of Byzantium*, London, 1958, Plate 24.

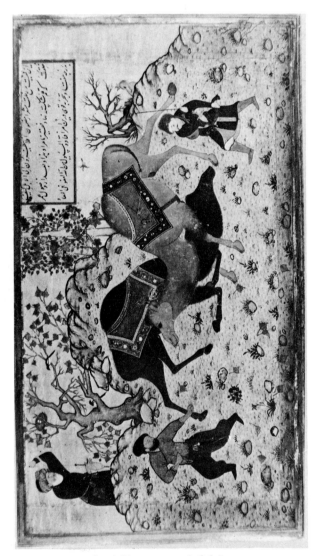

61. TABRIZ. Bihzad (?), *Two camels fighting*, c.AD 1525

Bibliography

Source material
Levi, Doro, *Antioch Mosaic Pavements*. Princeton, 1947.
Walker Trust. *The Great Palace of the Byzantine Emperors*. First
 Report, Oxford, 1947. Second Report (Ed. D. Talbot Rice).
 Edinburgh, 1958.
Rice, Tamara Talbot. *Ancient Arts of Central Asia*. London, 1965
 (with full bibliographies).

General works and summaries of existing theories
Arnold, Sir T. *Painting in Islam*. Oxford, 1928.
 He stresses the importance of Sasanian and Manichaean survivals
 and notes the influence of Syriac manuscripts.
Aslanapa, Oktay. *Turkish Art*. Istanbul, 1961.
 He accords an exaggerated degree of importance to the role of
 Turkish speaking peoples.
Binyon, L., Wilkinson, J. V. S. and Gray, B. *Persian Miniature
 Painting*. Oxford, 1933.
 They stress the importance of Egypt, both as a centre of
 Hellenistic survivals and as that of a creative style.
Blochet, E. *Musulman Painting*. London, 1929.
 He holds that the only influence of any real consequence was
 that of the classical tradition.
Kuehnel, E. *La Miniature en Orient*. Paris, 1922.
 He accords importance to the role of the Manichaeans and
 Nestorians, as well as that of Sasanian art.
Lorey, E. de. 'L'Hellenisme et l'Orient dans les Mosaiques de la
 Mosquée des Omayyades', in *Ars Islamica*, I (1934) 22. Also
 'Peinture Musulmane ou Peinture Iranienne', in *Revue des Arts
 Asiatiques*, XII (1938) 212.
 A balanced account of the various influences, stressing the
 importance of the Arabs of Mesopotamia.
Martin, F. R. *The Miniature Painting and Painters of Persia,
 India and Turkey*. London, 1912.

He thinks that Islamic painting followed a natural course of development from Classical and Byzantine art until the Persian contribution began to make itself felt in the thirteenth century.

Schulz, P. W. *Die Persisch-islamische Miniaturmalerei*. Leipzig, 1914.

He assigns considerable importance to the Sasanian origins of the art.

Stchoukine. I. *La Peinture iranienne sous les derniers Abbasides et les Il-Khans*. Bruges, 1936.

He notes the importance of Sasanian elements, into which Central Asian elements have been assimilated. But the principal motivation in the creation of a school of Islamic painting was Persia.

Chapter Two. The Omayyad Period

Berchem, M. van. 'The Mosaics of the Dome of the Rock and of the Great Mosque at Damascus', in K. A. C. Creswell, *Early Muslim Architecture*, Vol. I. Oxford, 1932.

Ettinghausen, R. *Arab Painting*. Skira, 1962.

Gibb, H. A. 'Arab-Byzantine Relations under the Umayyad Caliphate', in *Dumbarton Oaks Papers*, no. 12, 1958.

Hamilton, R. W. *Khirbat al Mafjar*. Oxford, 1959.

Musil, A. *Kusejr Amra*. Vienna, 1907.

Sauvaget, J. *La Mosquée omayyade de Médine*. Paris, 1947.

Schlumberger, D. 'Deux fresques Omayyades', in *Syria*, XXV (1946/48) 86.

Villard, U. Monneret de. *Introduzione allo Studio dell'Archeologia Islamica – Le Origini e il periodo Omayyade*. *Venice*, 1966.

Chapter Three. The Abbasid Period

Dorn, K. Otto-. 'Türkisch-Islamisches Bildgut in den Figuren-reliefs von Achthamar', in *Anatolia*, VI (Ankara, 1961).

Ettinghausen, R. *Arab Painting*. Skira, 1962.

Herzfeld, E. *Die Malereien von Samarra*. Berlin, 1927.

Rice, D. S. 'Deacon or Drink? Some paintings from Samarra explained', in *Arabica*, V (Leiden, 1958).

Sarre, F. and Herzfeld, E. *Die Ausgrabungen von Samarra*. Berlin, 1923-48.

Schlumberger, G. 'Le Palais Ghasnevid de Lashkari Bazaar', in *Syria*, XXIX (1952) 251.

Wilkinson, C. and others, 'Excavations at Nishapur', in *Bulletin of the Metropolitan Museum of New York*, XXXI (1936) XXXII (1936/37) XXXIII (1937/38) and XXXVII (1942).

Chapter Four. Egypt, Spain and North Africa
Arnold, Sir T. and Grohman, A. *The Islamic Book*. 1929.
Ettinghausen, R. 'Painting in the Fatimid Period—a reconstruction', in *Ars Islamica*, IX (1942) 112.
Gray, B. 'A Fatimid drawing', in *The British Museum Quarterly*, XII, no. 3, (1938) 92.
— 'An Islamic Charm from Fostat', in *The British Museum Quarterly*, IX (1935) 230.
Marçais, G. 'Plafonds peints du IX siècle à la grande Mosquée de Kairouan', in *Revue des Arts Asiatiques*', IX (1935).
Villard, U. Monneret de. *Le Pitture musulmane al Soffito della Capella Palatina in Palermo*. Rome, 1950.
Wiet, G. 'Un dessin du XI siècle' in *Bulletin de l'Institut d'Egypte*, XIX (1936/37) 223.
— 'Une peinture du XII ième siècle', in *Bulletin de l'Institut d'Egypte*, XXVI (1944).

Chapter Five. The Mesopotamian School
Aga Oglu, M. 'On a manuscript of Al-Jaziri', in *Parnassus*, III (1931) 27.
Bishr Fares. *Le Livre de la Thériaque*. Institut d'Archéologie Orientale de Caire, 1953.
— *Une Miniature religieuse de l'École Arabe de Bagdad*. Cairo, 1948.
— *Vision Chrétienne et Signes Musulmans*. Cairo, 1961.
Blochet, E. *Musulman Painting*. London, 1929.
Buchthal, H. 'Early Islamic Miniatures from Baghdad', in *Journal of the Walters Art Gallery*, no. V. 1942.
— 'Hellenistic Miniatures in early Islamic Manuscripts' in *Ars Islamica*, VII (1940) 125.
— Kurz, O. and Ettinghausen, R. 'Supplementary Notes on K. Holter's Check List', in *Ars Islamica*, VII (1940) 147.
Ettinghausen, R. *Arab Painting*. 1962.
Holter, K. 'Die Galenhandschrift und die Makamen des Hariri der Wiener Nationalbibliothek', in *Jahrbuch der kunsthistorischen Sammlungen in Wien*, XI (1937) 1.
— 'Die islamischen Miniaturhandschriften vor 1350', in *Zentralblatt für Bibliothekswesen*, Vol. 54.
Jerphanion, R. P. de. *Les Miniatures du Manuscrit Syriaque No. 559 de la Bibliothèque Vaticane*. Vatican, 1940.
Kuehnel, E. 'Die Bagdader Malerschule aus der Ausstellung iranischer Kunst in Paris', in *Pantheon*, XIX (1939).
Löfgren, O. *Ambrosian fragment of an illuminated Manuscript containing the Zoology of Al Ghariz*. Upsala, 1946.

Lorey, E. de. 'L'École de Bagdad', in *Gazette des Beaux Arts*,
Riefstahl, R. H. 'The Date and Provenance of the Automata
 Miniatures', in *Art Bulletin*, XI (1929) 208.
Stchoukine, I. *La Peinture iranienne sous les derniers Abbasides et
 les Il-Khans*. Bruges, 1936.
Walzer, S. 'The Mamluk illuminated Manuscripts of Kalila wa
 Dimna', in *Aus der Welt der islamischen Kunst*, Festschrift für
 Ernst Kuehnel, p. 195. Berlin, 1959.

Chapter Six. The Il Khanid School
Aga Oglu, M. 'Preliminary Notes on some Persian Illustrated
 Manuscripts in the Topkapu Sarayi Müzesi', in *Ars Islamica*,
 I (1934).
Barret, D. *Persian Painting of the Fourteenth Century*. London,
 1952.
Brian, Doris. 'A Reconstruction of the Miniature Cycle in the
 Demotte Shah Namah', in *Ars Islamica*, VI (1939) 97.
Gray, B. *Persian Painting*. Skira, 1961.
—'Fourteenth Century Illustrations of the Kalilah and Dimnah',
 in *Ars Islamica*, VII (1940) 134.
Lorey, E. de. 'L'École de Tabriz—l'Islam aux prises avec la
 Chine', in *Revue des Arts Asiatiques*, IX (Paris, 1935) 27.
—'Le Bestiaire de l'Escurial', in *Gazette des Beaux Arts*, Dec.
 1935.
Schroeder, E. *Persian Miniatures in the Fogg Museum of Art*.
 Harvard, 1942.
—'Ahmed Musa and Shams al, Din; a Review of Fourteenth
 Century Painting', in *Ars Islamica*, VI (1939).
Stchoukine, I. 'Les Peintures du Shah-Nameh Demotte', in *Arts
 Asiatiques*, V (1958).
— *La Peinture iranienne sous les derniers Abbasides et les Il-Khans*.
 Bruges, 1936.

Chapters Seven and Eight. Persian Painting from c. 1400
Binyon, L. *The Poems of Nizami*. London, 1928.
Binyon, L., Wilkinson, J. V. S. and Gray, B. *Persian Miniature
 Painting*. Oxford, 1933.
Gray, B. *Persian Painting*. Skira, 1961.
Guest, G. D. *Shiraz Painting in the Sixteenth Century*. Washington,
 1949.
Robinson, B. W. *A Descriptive Catalogue of the Persian Paintings
 in the Bodleian Library*. Oxford, 1958.

Sakisian, A. *La Miniature Persane du* XII *au* XVIII*e siècle*. Paris and Brussels, 1929.

Stchoukine, I. *Les Peintures des Manuscrits Timurides*. Paris, 1954.

Wilkinson, J. V. S. and Binyon, L. *The Shah Namah of Firdausi*. Oxford, 1931.

Chapter Nine. Turkish Painting

Aslanapa, O. 'Türkische Miniaturmalerei am Hofe Mehmet des Eroberers in Istanbul', in *Ars Orientalis*, I (1954) 77.

Blauensteiner, K. and Wellecz, E. 'Beispiele Osmanischer Buchkunst aus der Zeit Sultan Selim II und Murat III', in *Wiener Beiträge zur Kunst und Kulturgeschichte Asiens*, X (1936) 34 and 35.

Edhem, H. and Stchoukine, I. 'Les Manuscrits orientaux illustrés de la Bibliothèque de l'Université de Stamboul'. *Mémoires de l'Institut français d'Archéologie de Stamboul*, Paris, 1933.

Ettinghausen, R., Ipşiroğlu, M. S. and Eyüboglu, S. *Turkey; Ancient Miniatures*, Unesco, 1961.

—'Some Paintings in Four Istanbul Albums', in *Ars Orientalis*, I (1954) 91.

Grube, E. J. 'A School of Turkish Miniature Painters', in *Proceedings of the First International Congress of Turkish Art*. Ankara, 1959.

—'Miniatures in Istanbul Libraries', in *Pantheon*, XX (1962).

Ipşiroğlu, M. S., and Eyüboglu, S. *Sur l'Album du Conquerant*. Istanbul University, 1960.

Meredith-Owens, G. M. *Turkish Miniatures*. The British Museum, 1963.

Minorsky, V. and Wilkinson, J. V. S. *The Chester Beatty Library. A Catalogue of the Turkish Manuscripts and Miniatures*. Dublin, 1958.

Nourallah, Berk. *La Peinture Turque*. Ankara. 1950.

Sakisian, A. 'Turkish Miniatures', *The Burlington Magazine*, LXXXVI and LXXXVII (1945).

Stchoukine, I. *La Peinture Turque d'après les Manuscrits illustrés. I. De Sulayman I à Osman II, 1520–1622*. Paris, 1966.